IMAGES
of America

GREATER BOSTON'S
BLIZZARD OF 1978

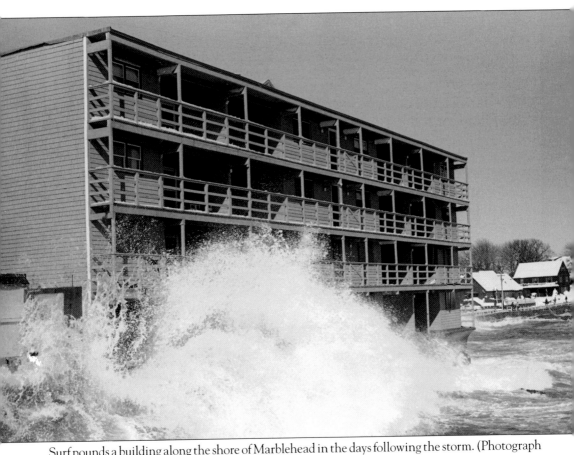

Surf pounds a building along the shore of Marblehead in the days following the storm. (Photograph courtesy of Michael Shavelson.)

IMAGES
of America

GREATER BOSTON'S
BLIZZARD OF 1978

Alan R. Earls
Introduction by Gov. Michael S. Dukakis

ARCADIA
PUBLISHING

Published by Arcadia Publishing
Charleston, South Carolina

Printed in the United States of America

Library of Congress Catalog Card Number: 2007929955

For all general information contact Arcadia Publishing at:
Telephone 843-853-2070
Fax 843-853-0044
E-mail sales@arcadiapublishing.com
For customer service and orders:
Toll-Free 1-888-313-2665

Visit us on the Internet at www.arcadiapublishing.com

CONTENTS

ACKNOWLEDGMENTS

In assembling the illustrations for this book and writing the text, I have received priceless assistance from a number of organizations including the U.S. Coast Guard; the staff of the National Archive and Records Administration in Waltham; Col. Leonid E. Kondratiuk and the Massachusetts Army National Guard; Donna Barr Tabor, command historian for the XVIII Airborne Corps and Fort Bragg; the National Weather Service; the public affairs office of the U.S. Army Corps of Engineers New England Division; Joseph E. Pelczarski at the Massachusetts Office of Coastal Zone Management; Don Wilding and the Henry Beston Society; and Amelia Auberg of the American Red Cross of Massachusetts Bay. In addition to these organizations and the individuals affiliated with them, I am indebted to numerous private individuals who took the time to search through files and scan and/or loan images. Those individuals include Jonathan L. Rolfe, Lillian Jabs and her family, Thomas E. Bonomi (who also provided connections to James Bonomi, Henry Nilsen, Eleanora Mulroy, and the Wilbur B. Kennedy family of Quincy), George S. Watson, Leslie Scott-Lysan, Douglas Wynne, John Harney, Jack Mileski, Michael B. Shavelson, Eric Pence, Ken Glass, Wayne M. Itano, and Frank Florianz. Special thanks are due to Bruce Simons for his in-depth blizzard website (http://hullnantasket.homestead.com/) and for sharing his own photographs and those of Rosalyn Simons and Elmer Pooler. Finally I am very grateful to former Gov. Michael S. Dukakis for his time and ideas, as well as the introduction he has graciously penned for this volume. If any other individual or organization has been omitted from this list, the oversight is unintentional.

INTRODUCTION

"Planning" is not a particularly sexy word, nor is it often invoked to describe great achievements in public service. But planning made all the difference in 1978 for a young governor who was trying to deal with one of the great storms of the century.

I was the governor of Massachusetts when the Commonwealth and New England were hit with a blizzard of almost unprecedented proportions. Much has been said and written about how we tried to cope with it, and most of the reviews were pretty good, but most of those accounts ignored what was an absolutely critical ingredient in how we responded—the importance of planning in advance and the key role that my secretary of public safety, Charlie Barry, played in that effort.

Barry was a 32-year veteran of the Boston police force when I recruited him to be my first—and only—secretary of public safety. I was a strong advocate for community policing even back in the days when nobody was using the phrase, and I wanted a state public safety secretary who had walked a beat, commanded beat patrol officers, and was prepared to take that message to high crime neighborhoods all over the Commonwealth.

What I didn't realize when I recruited him was that Barry was obsessively committed to emergency planning—something which certainly wasn't at the top of my priority list. And thank God he was, because when the snow started falling and the wind started blowing on that fateful day in 1978, we were ready, thanks to Barry's obsession.

In fact, he had asked me a couple of weeks before the blizzard for a half-hour's time at an upcoming cabinet meeting to go over the latest revision of the state's emergency plan. I tried to put him off, but he insisted, and how could you refuse Barry? So sure enough, we took a short half-hour so that he could distribute copies of the new plan, which must have been five inches high, and discuss it toward the end of that cabinet meeting.

Fortunately he insisted, and I relented, and when the storm hit us, we were ready. Cabinet secretaries and commissioners knew what they were supposed to do. Folks in the field had their assignments, and while I probably should have urged people to leave work earlier and get home before the snow started piling up, all in all we handled things pretty well, and most people felt good about how the state and its cities and towns responded to the crisis that hit us.

All but emergency traffic was banned. Social services and hot meals were delivered. People stuck on Route 128 had a very difficult night, but nearly all of them came through the ordeal. And the people of the Commonwealth came together in their hour of need with a sense of camaraderie and cooperation that we hadn't experienced in a long time.

In fact, my wife, Kitty, took our two daughters to the Beth Israel Hospital, which is a 10 minute walk from our house in Brookline, to volunteer in whatever way they could, and while

the coordinator of volunteers was appreciative, she confided to Kitty privately that she had so many volunteers that she couldn't use all of them.

In the meantime, I was on television every afternoon in a sweater trying to advise people about what to do, but off camera, Barry was feeding me my lines. I had complete confidence in him and his team, and that confidence was certainly justified by the way in which he and hundreds of outstanding state employees did their jobs.

Of course, one might ask why I lost the Democratic primary just a few months later if, with his leadership, we had done such a great job in handling the storm. Bill Bulger, my senate president when I returned to the State House in 1983, claimed that it was because I forced husbands and wives to stay in the house together for a full week, and they got so mad, they took it out on me at the September primary.

Maybe so, but if ever a case could be made for competent, professional advance planning in the face of potential emergency situations, Barry's leadership in the winter of 1978 in an eloquent testimonial to that reality. The photographs in this book are a reminder of what we went through and give a hint of just how bad things could have been if we had not been blessed with his foresight.

Too bad nobody in the executive branch of the federal government paid attention to that lesson in the fall of 2005. Things might have been a lot better in the city of New Orleans.

—Michael S. Dukakis

One

CAUGHT BY SURPRISE

To be sure, there were some people who expected and perhaps were even prepared for the blizzard of 1978, but they were a tiny minority. For most, it was not until well into the afternoon of the first day, Monday, February 6, that it became clear the storm was going to be substantial in its impact. Although some companies and government agencies let employees leave early, many did not. And life went on more or less normally, until the storm made that impossible. By late afternoon, things had begun to get desperate for commuters stuck in traffic that often would not and could not move.

And, on the coast, the most ominous aspect of the storm was becoming apparent—it was building up on-shore winds of tremendous velocity at just the time and place when tides were already unusually high. It was a tragedy in the making.

Most people experienced the storm through its impact on transportation. Douglas Wynne, who lived in Norwood at the time, recalled starting the day of the storm in Saugus. When he called his wife Judy at midday, she told him the storm was getting bad in Rhode Island and points southwest of Boston, so he decided to cancel his plans and head home via the Mystic River Bridge. Things went well until he crossed the Neponset River on the Southeast Expressway, at which point traffic ground to a halt. Opting to take his chances on the secondary roads, Wynne got as far as Sharon when his Mercury Comet was stymied by hood-height snow drifts. After wending his way through a variety of alternate routes, Wynne finally managed to get into his driveway five and a half hours after departing Saugus.

When the author drove to the western suburbs from Cambridge around 7:00 p.m., there was not another car in sight and numbered routes and secondary roads consisted of nothing more than two ruts in standing snow of 12–18 inches depth.

Leslie Scott-Lysan, a student at Bridgewater State College at the time and part of the staff of WBIM, the student-run radio station at the school, was one of only two staff members on campus able to make it to the facility during the blizzard. Because WBIM was designated as part of the emergency broadcast system, the transmitter had to run 24/7 while the state of emergency was in effect so the pair did their best to keep up the music and talk, but at times all they could manage was dead air.

The storm itself was the result of three weather systems combining into an on-shore storm known locally as a northeaster, now commonly known as nor'easter. One system formed over the Atlantic, another around western Pennsylvania, and still another in the Southeast. A persistent high pressure area over Canada effectively anchored the mature storm over New England where its rotating bands of snow and sustained winds of more than 60 miles per hour and wind gusts of

100 miles per hour made it a destructive presence for nearly two days. At its peak, snow fall rates of up to four inches per hour were recorded and drifts as high as 15 feet were reported.

And it was a large storm, impacting areas from New York and New Jersey up into northern New England. Dr. Jeffrey Lamont, a Boston-area urologist who was then a student at Dartmouth College, recalls that the entire campus, with the sole exception of the facility where he was taking a chemistry exam, was shut down by the storm, an extremely rare event in the school's long history.

Along the coast and at sea, especially within Massachusetts Bay, which acted to trap the winds and tide, the blizzard was at its most terrifying. At the storm's peak, according to the Massachusetts Office of Coastal Zone Management, the ocean rose 15.2 feet above mean low water. Coastal flooding begins with anything greater than 13.6 feet above mean low water. And that's without making allowances for the high, wind-driven surf that added strength to the flowing water and the fact that the storm lasted through two high-tide cycles. These factors, together, contributed to the destruction of some 2,000 buildings near the shore.

Roadways, seawalls, and even the landscape itself were also victims. The Pamet River near the tip of Cape Cod was dredged into a full-fledged tidal passage between Massachusetts Bay and the Atlantic Ocean. And almost every beach in the region was significantly reshaped by the storm.

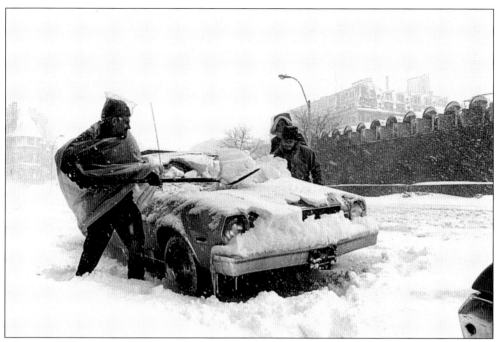

Clearing cars of snow and keeping them clear was the first challenge for those braving the storm. Here drivers and passengers work to get a Ford Pinto out of its parking spot in Kenmore Square. (Photograph by Ken Glass.)

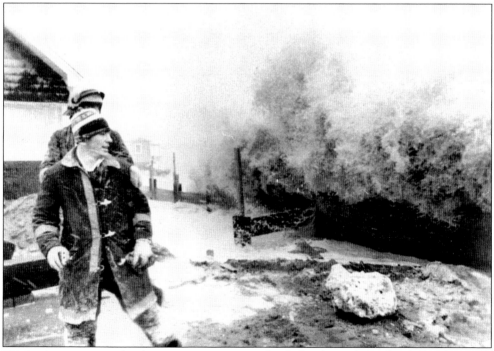

While the snow was the dominant experience inland, for those along the shore, the rising tides, surf, and winds gave an early indication that the storm was going to be of memorable dimensions. (Photograph courtesy of U.S. Army Corps of Engineers.)

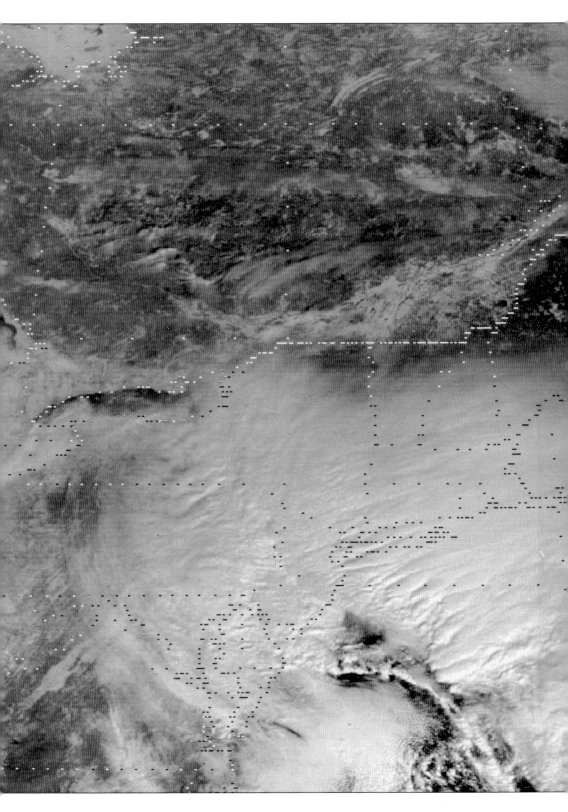

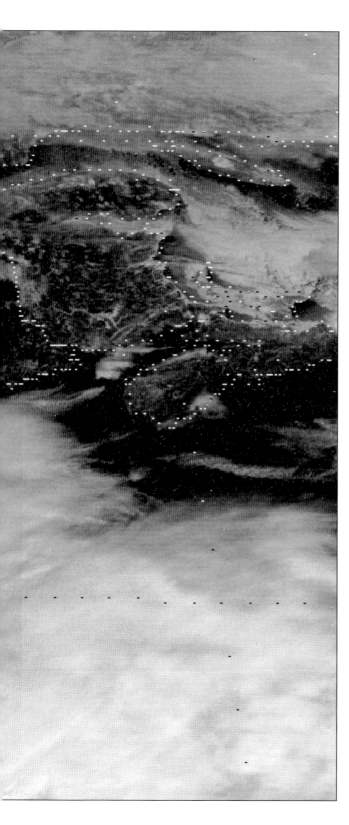

This satellite image from February 6, 1978, shows the storm approaching the southern coast of New England. At this point, there were few who expected it to turn into the furious monster it became. (Photograph courtesy of U.S. Army Corps of Engineers.)

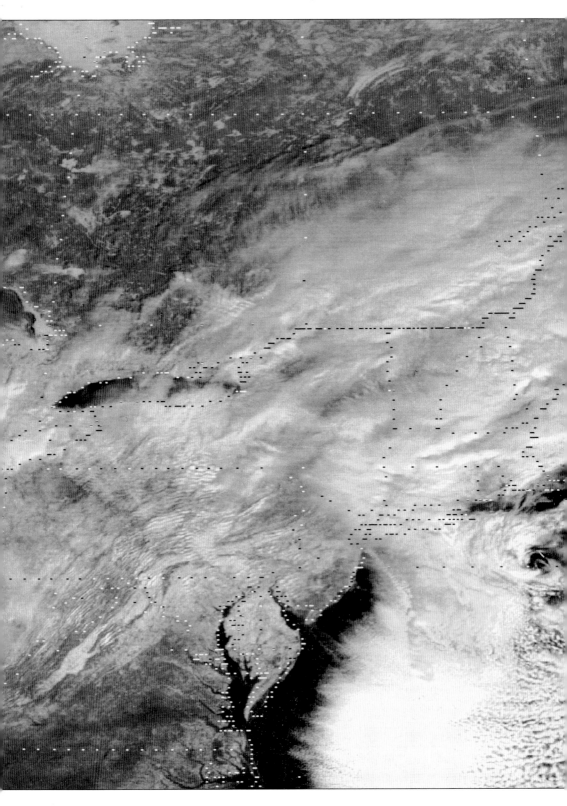

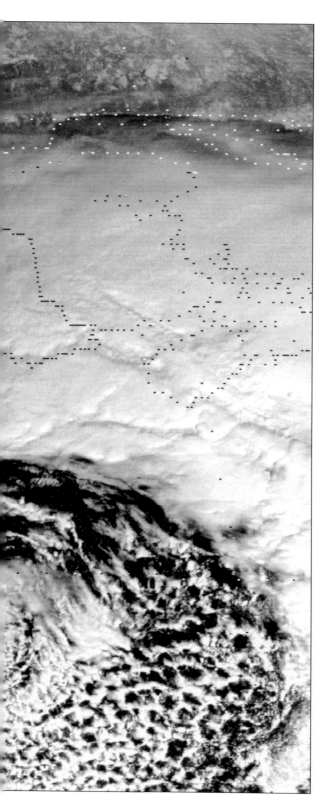

By February 7, when a weather satellite captured this image, the cyclonic pattern of the storm is clear. It was this, combined with unusually high tides, that led to so much coastal damage. (Photograph courtesy of U.S. Army Corps of Engineers.)

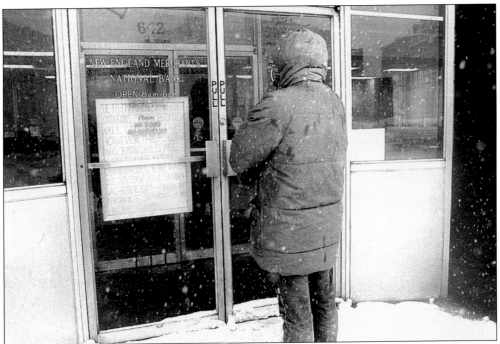

Although businesses rarely closed for snow, by late on the afternoon of Monday, February 6, many were deciding this storm was different, including this branch of the New England Merchants National Bank. (Photograph by Ken Glass.)

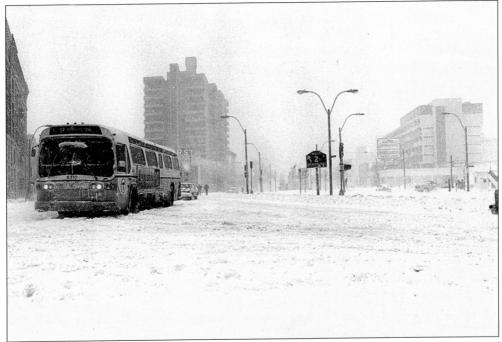

One reason so few pedestrians are visible in this image of Kenmore Square is the fierceness of the wind and snow, which made public transportation, while it continued to operate, a welcome relief. (Photograph by Ken Glass.)

The lines were long to board busses such as this one entering the Kenmore Square station. (Photograph by Ken Glass.)

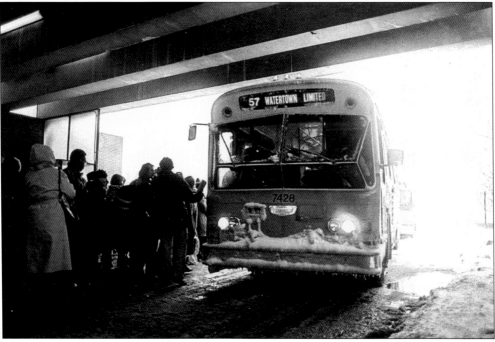

The Watertown Limited offered relative warmth and a respite from the storm for those lucky enough to get aboard. However, the ride to Watertown was probably extremely slow since cars and even trucks were beginning to bog down in the heavy snow. (Photograph by Ken Glass.)

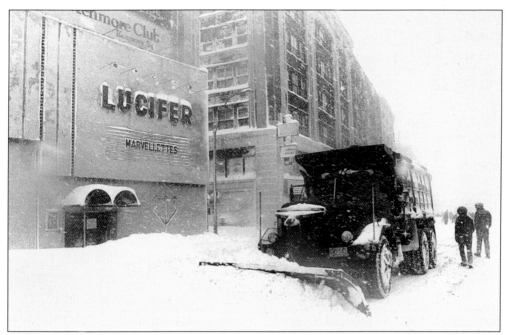

Although it was cold and getting colder, Lucifer, the Kenmore Square nightclub, proved to be an irresistible photographic backdrop for tracing the blizzard's impact. Here a snowplow is trying to keep up with the precipitation. (Photograph by Ken Glass.)

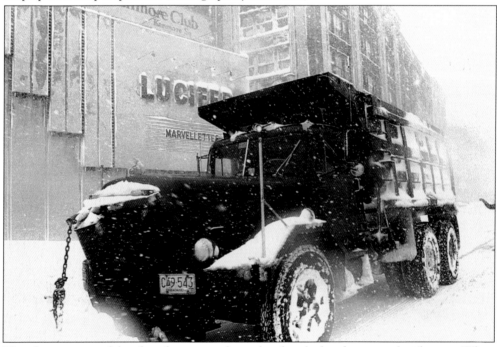

This close up view of the plow shows a machine already caked and encrusted with snow. When traffic stoppages began to make roads impassible and the plows were thus unable to make regular passes, the snow began to reach depths that became difficult or impossible to plow with conventional rigs. (Photograph by Ken Glass.)

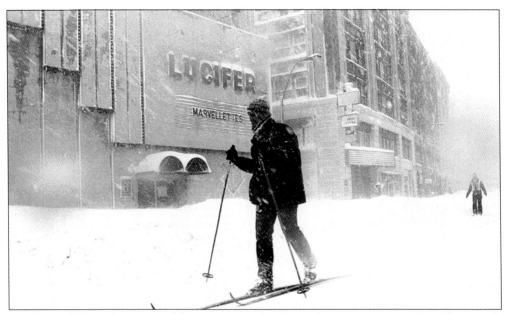

It did not take long for resourceful Bostonians to break out their cross-country skis. (Photograph by Ken Glass.)

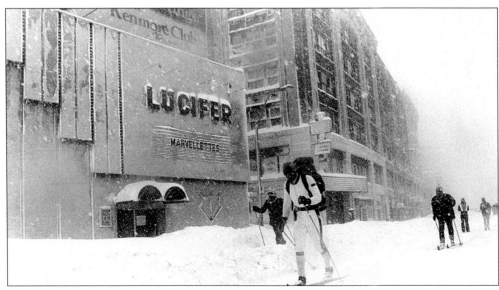

With three skiers visible in this one frame, it almost seems as if Kenmore Square is heading for a new kind of gridlock. (Photograph by Ken Glass.)

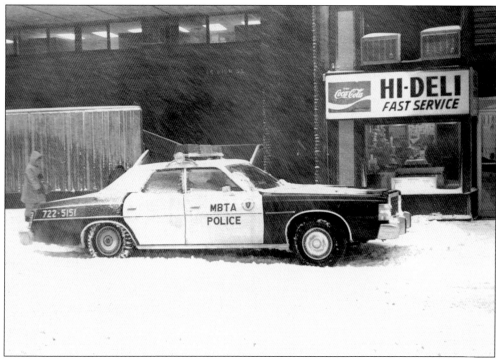

The nearly horizontal movement of the snowfall can be seen in this image of a transit police vehicle in front of the Hi-Deli on High Street in Boston. (Photograph by Frank Florianz.)

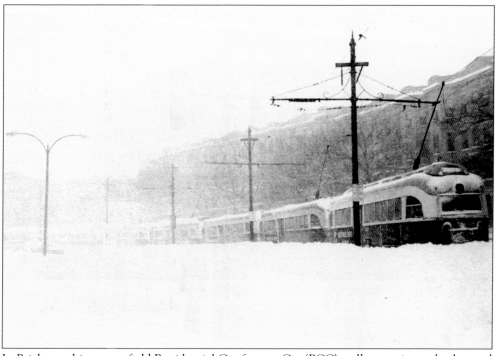

In Brighton, this group of old Presidential Conference Car (PCC) trolley cars is nearly obscured by the falling snow. (Photograph by Frank Florianz.)

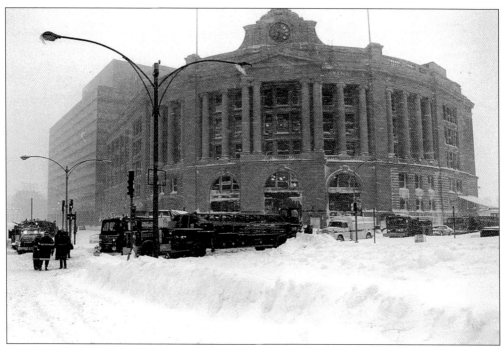

Boston firefighters are standing by in this image taken in front of South Station in Dewey Square, Boston. If the clock is accurate, the photograph may have been taken on the morning of the second day of the blizzard. (Photograph by Ken Glass.)

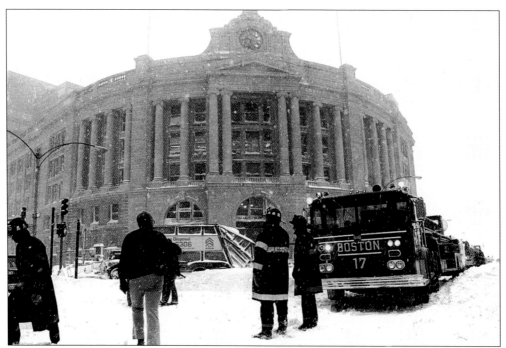

The falling snow can be clearly seen in this image. In contrast to some highways that became totally blocked, most of the main city streets remained passable, at least to emergency vehicles.

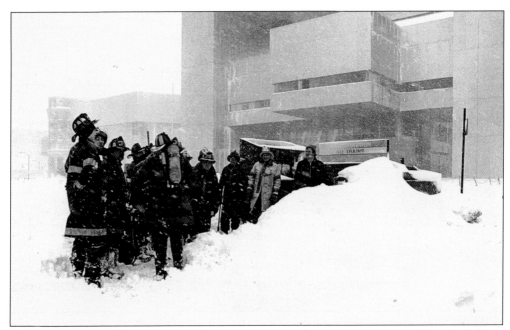

A continuation of the sequence on the previous page, this image appears to show firefighters preparing to enter the Red Line station. The nature of the emergency is not recorded. (Photograph by Ken Glass.)

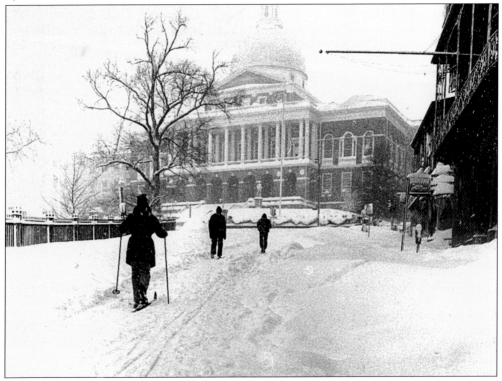

This stately postcard view of the State House, looking up Park Street, shows the city in the grip of the blizzard's enforced calm. (Photograph by Ken Glass.)

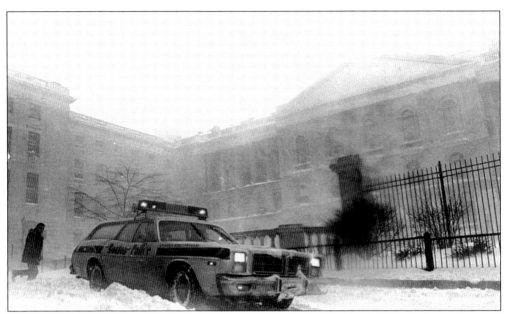

A Boston police cruiser creeps past the rear of the State House as the snow continues to fly. (Photograph by Ken Glass.)

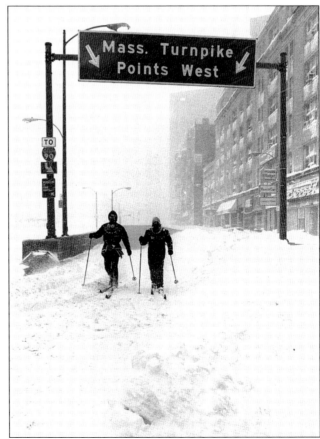

It was the major roads that often were most affected by the blizzard. Here, cross-country skiers face no competition from cars at the Back Bay entrance to the Massachusetts Turnpike. (Photograph by Ken Glass.)

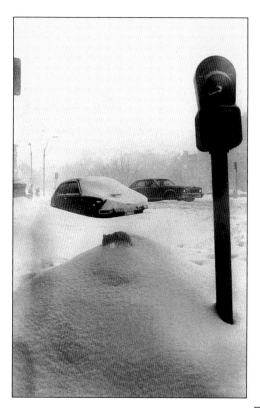

In this "before" shot, taken early in the blizzard, a sentinel-like parking meter still stands largely untouched by the accumulating snow. (Photograph by Ken Glass.)

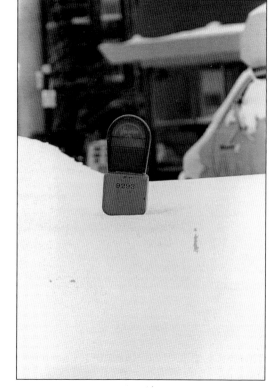

Later in the storm, parking meters, like this nearly buried unit, became a good indicator of snow depth, though because of drifting, snow depths often varied dramatically. (Photograph by Ken Glass.)

The first round games of the annual Beanpot Hockey Tournament were in progress at Boston Garden the evening of the blizzard. These revelers found a place to celebrate despite the storm, which closed down public transit by the time the games ended for the evening. (Photograph by Ken Glass.)

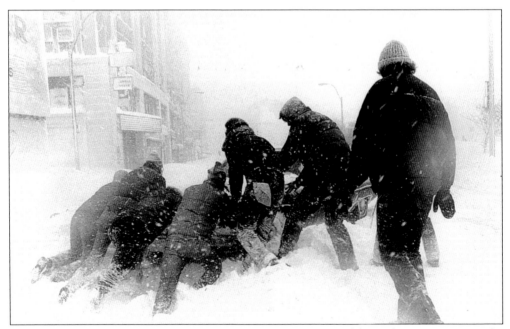

This image shows how daunting it was to get cars moving—and keep them moving—in the rising tide of snow. (Photograph by Ken Glass.)

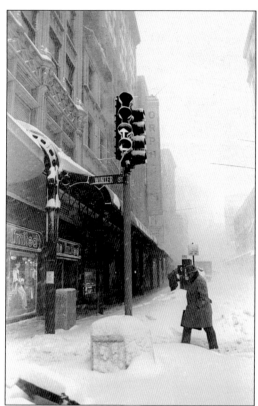

Here a lone pedestrian struggles through the snow along Washington Street in downtown Boston. (Photograph by Ken Glass.)

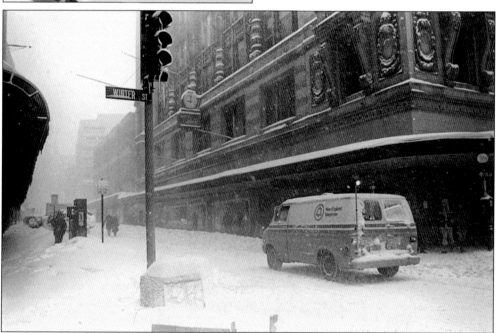

A New England Telephone truck (reminding one that the blizzard pre-dated the breakup of the Bell System) drives down Washington Street in front of Filene's department store. (Photograph by Ken Glass.)

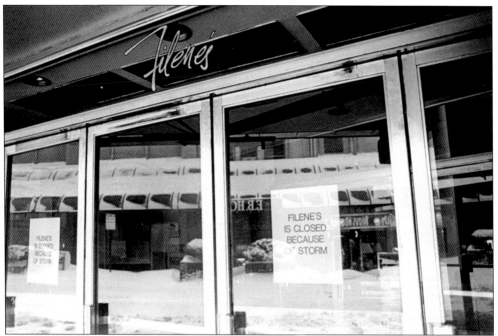

Another reason for the lack of pedestrians was simply that most merchants, including Filene's, had closed up and sent their workforce home early. (Photograph by Ken Glass.)

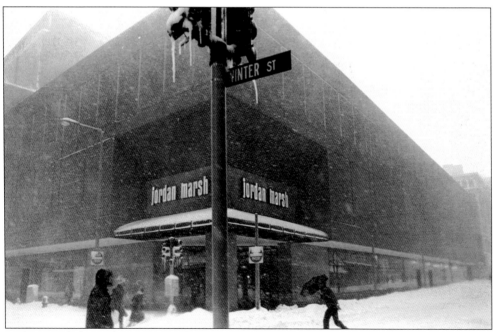

Jordan Marsh (or Jordan's as it was familiarly called) was also closed up tight leaving pedestrians few places to shelter and no reason to linger along Washington Street. (Photograph by Ken Glass.)

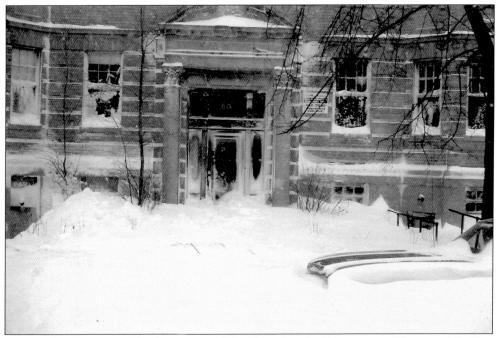

A snowed-in doorway marks the progress of the blizzard in the Fenway area. (Photograph by Eric Pence.)

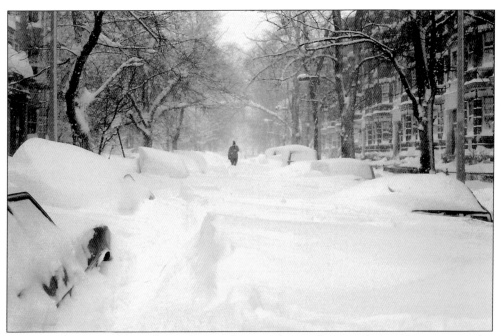

Cars have disappeared from the roadway and are nearly out of view in their parking spots in this image of the Fenway. (Photograph by Eric Pence.)

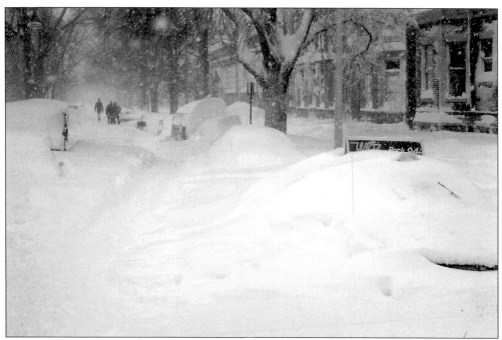

The only visible element of the taxi in the foreground is the sign advertising FM radio station WCOZ. (Photograph by Eric Pence.)

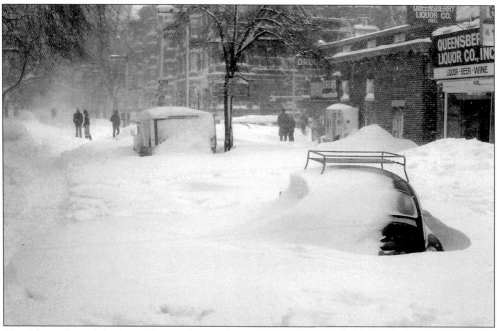

The blizzard quickly cleaned out the stock at many stores, probably including Queensberry Liquor, shown here. (Photograph by Eric Pence.)

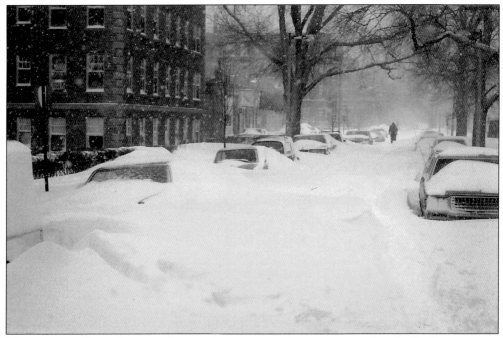

More cars are shown in repose here as the snow continues to accumulate in the Fenway area. (Photograph by Eric Pence.)

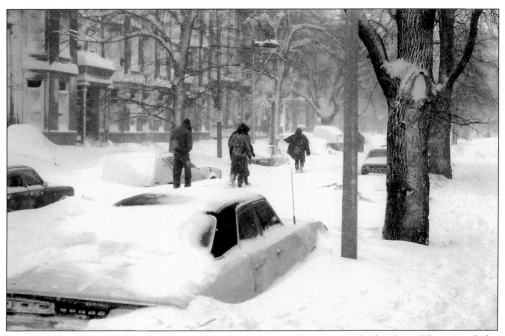

Some walkers braved the elements to stock up on supplies or simply for fun. (Photograph by Eric Pence.)

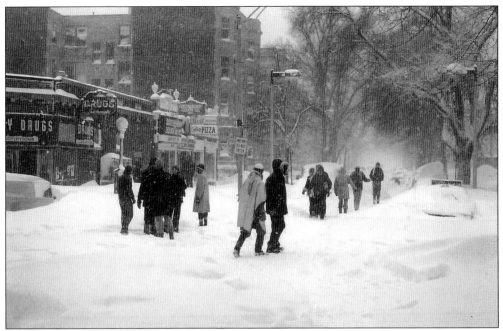

The stores appear to be closed as this crowd of pedestrians huddles outside. (Photograph by Eric Pence.)

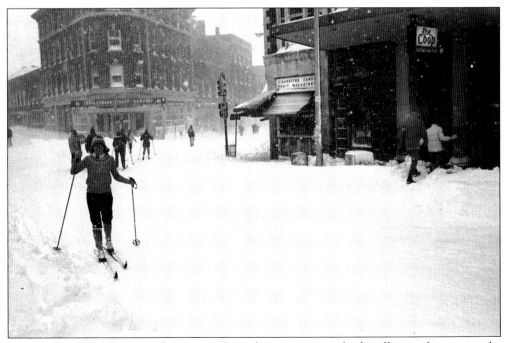

Even as the snow fell, Harvard Square took on the appearance of a ski village and maintained a festive gaiety until the driving ban was lifted a week later. (Photograph by Wayne Itano.)

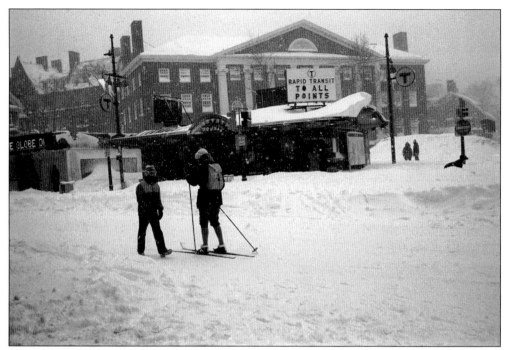

The old Harvard Square T entrance, with the wooden steps of its ancient escalator, beckoned travelers but in many cases T operations had come to a stop due to the blizzard. (Photograph by Wayne Itano.)

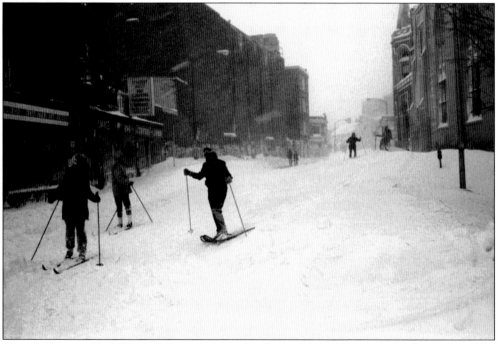

Church Street, off of Harvard Square, is nearly obscured by falling snow in this image. The Unitarian church is to the right. (Photograph by Wayne Itano.)

Two

IMMEDIATE AFTERMATH

As the storm abated, it left a stunning and unfamiliar landscape. Houses, cars, hedges, and roads were all masked by deep and drifting snow that plows had, in most cases, been unable to stem it in the least. It was a moment of isolation and of community. Famously Gov. Michael Dukakis, broadcast over local TV stations from his ad hoc operations center near the State House, appeared on camera in casual garb—a sweater that seemed as comfortable and reassuring as Mr. Roger's famous cardigan.

The tone he set and the actions he took—banning car traffic and more or less shutting down the state through an emergency declaration—were widely applauded. The emergency declaration provided time and resources for public safety workers and road crews to try to get things back to normal. Indeed for many people, the succeeding days became a pleasant frolic, a time to share with friends and family.

Of course, the dark side of the blizzard was not far away. Mountainous seas had snuffed out the lives of several mariners and up and down the length of Massachusetts Bay and coastal communities were heavily damaged and in some places nearly erased. It was here that most of the state's loss of life and property occurred.

Hundreds of motorists were also trapped in their cars along sections of Route 128. In areas where there were power failures or where the storm had damaged housing, about 17,000 people had been moved into shelters and another 10,000 were otherwise evacuated from vulnerable sites. Notable losses along the coast included Motif No. 1 in Rockport; the *Peter Stuyvesant*, a former Hudson River steamer that restaurateur Anthony Athanas had moored alongside his Pier Four restaurant in Boston as a special events facility; and the Outermost House. This last building, a mere beach shack located two miles south of the Nauset Coast Guard Station on Cape Cod, was made famous by the Thoreau-like writings of author Henry Beston, based on the year he spent there in the mid-1920s.

The worst damage was concentrated in seven Massachusetts towns, which together suffered half of the total property damage incurred by the storm. The towns were Plymouth, Marshfield, Scituate, and Hull on the South Shore and Revere, Lynn, and Gloucester on the North Shore.

Even where the storm was less destructive, it still made daily life a sobering experience. Innumerable families awoke to discover that their doors were completely blocked by snow, often necessitating exit through an upper-story window. Supplies of almost everything ran low, from the cabinets of individual family kitchens to local stores and area warehouses. People had to suddenly learn to "make do." Lengthy power failures were commonplace, too.

To supplement the recovery efforts of local governmental organizations and the Massachusetts National Guard, Fort Bragg in North Carolina dispatched 200 soldiers and their equipment in some 27 C-130 and C-141 flights (many of those involved had just completed a deployment to help Indiana dig out from their own separate, record-breaking blizzard of 1978—a storm that had struck on January 25). However, it took a mammoth effort at Logan Airport just to dig out enough of the runways to permit the incoming flights to land.

In the final analysis, the storm may not have quite reached the destructive milestones set by the great blizzard of 1888, which was blamed for 400 deaths from Chesapeake Bay to the Canadian Maritimes and saw many areas with snow accumulations above 50 inches, but it came very close.

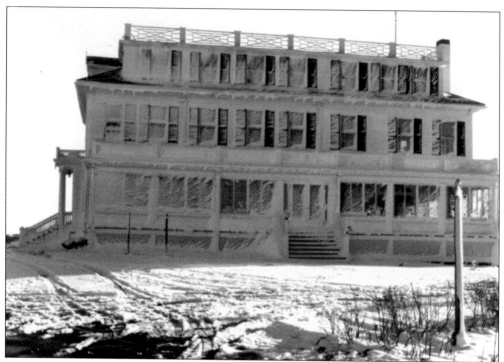

In the aftermath of the storm, this structure at Bass Rocks in Gloucester was covered with wind-blown snow and ice. (Photograph by Joseph E. Pelczarski.)

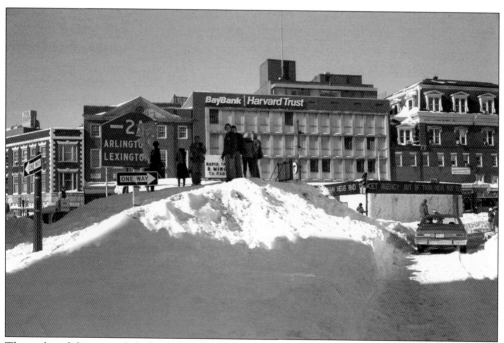

The wake of the storm left Cantabrigians blinking in amazement. Here a single narrow lane (at the right) is all that is left of Massachusetts Avenue. (Photograph by Wayne Itano.)

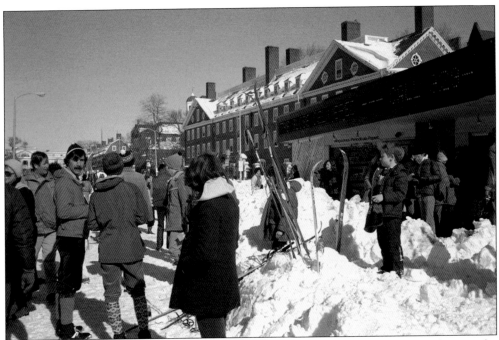

With its abundance of students and young people, Harvard Square soon became as busy in the aftermath of the blizzard as it would have been normally—though the mode of transportation was different. (Photograph by Wayne Itano.)

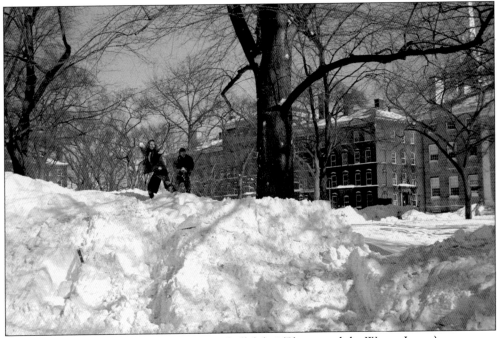

With all that snow, who could resist a snowball fight? (Photograph by Wayne Itano.)

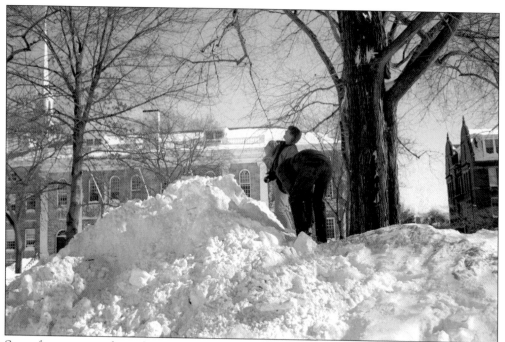

Snow forts were ready-made thanks to piles left by snow removal equipment in Harvard Yard. (Photograph by Wayne Itano.)

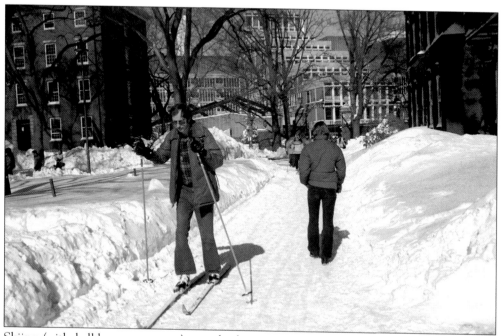

Skiing (with bell-bottom trousers) was the best way to get around campus. (Photograph by Wayne Itano.)

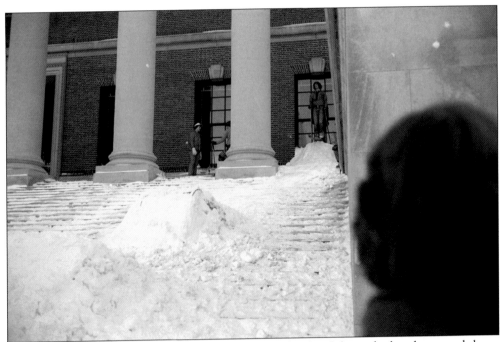

More daring folks strapped on alpine skis and prepared to head down the hand-groomed slopes of the Widener Library steps at Harvard University. (Photograph by Wayne Itano.)

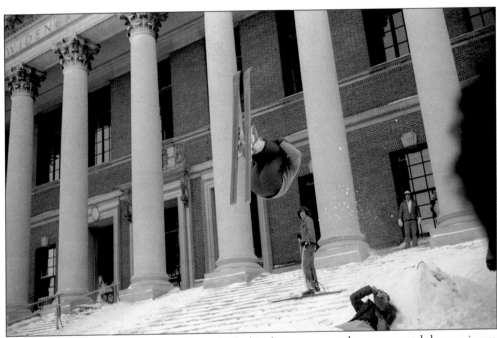

Students even built a modest jump from which this skier appears to have extracted the maximum benefit. (Photograph by Wayne Itano.)

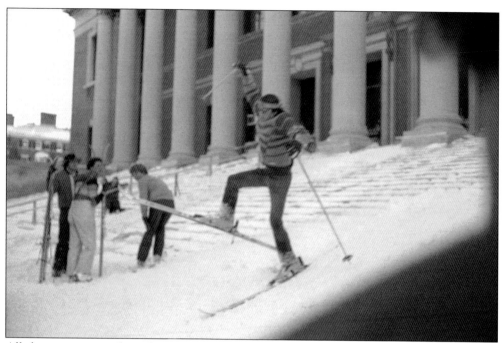

All that was missing from the steps was a ski lift, and if time had permitted, perhaps that too would have been devised. (Photograph by Wayne Itano.)

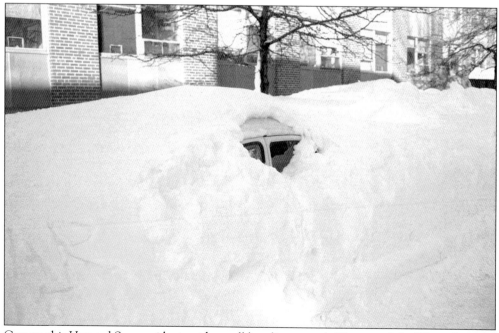

Cars on this Harvard Square side street have all but disappeared. (Photograph by Wayne Itano.)

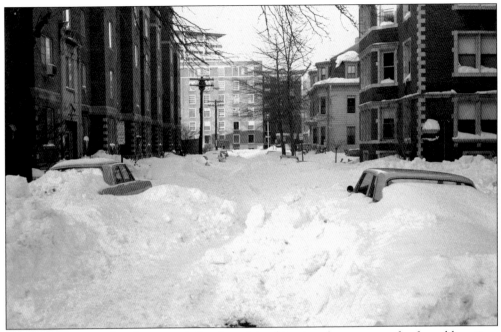

Another side street has been partially cleared in this view, but cars are far from liberation. (Photograph by Wayne Itano.)

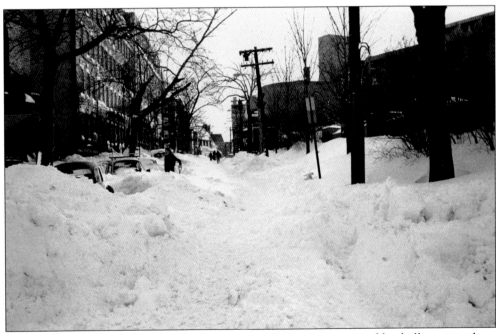

The chaos of snow piles and snowdrifts presented almost insurmountable challenges to those trying to free their cars. (Photograph by Wayne Itano.)

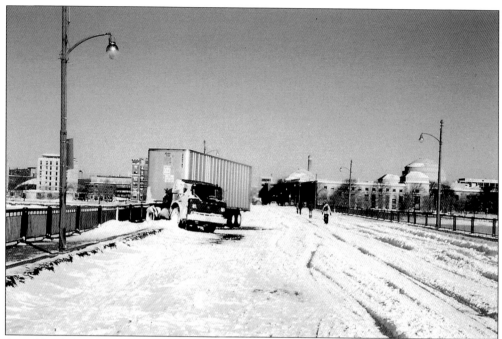

A jackknifed tractor trailer along the snow-clogged Massachusetts Institute of Technology (MIT) bridge would normally have attracted news cameras and emergency crews but not when the blizzard of this magnitude was in town. (Photograph by Eric Pence.)

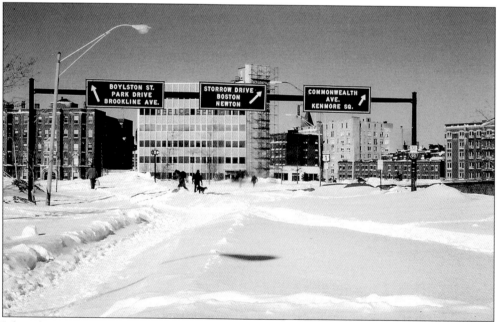

Like other major highways, the blizzard cleared this normally busy section of parkway near the Fenway, leaving it for pedestrians and skiers. (Photograph by Eric Pence.)

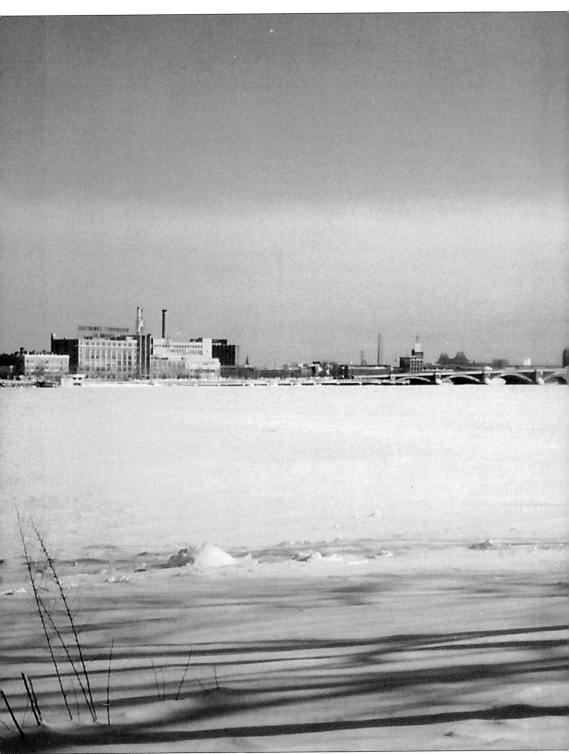

Looking downriver from near Boston University, the Charles River is snow covered and still. With time on their hands and faltering public transportation, many individuals risked walking

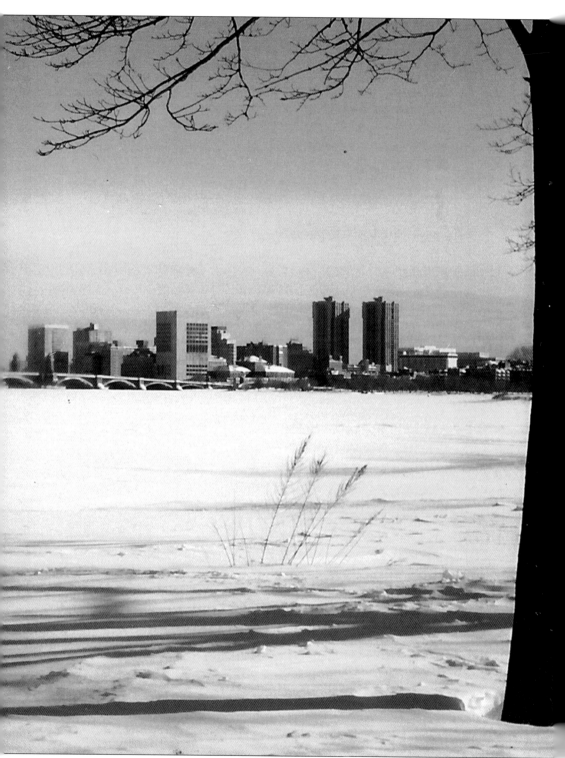

across the frozen river. (Photograph by Eric Pence.)

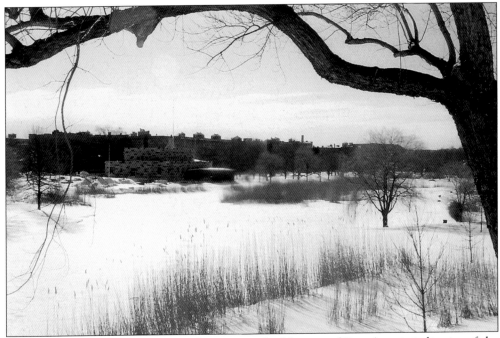

This idyllic view of the snow covered Fens, near the Museum of Fine Arts, is indicative of the whole post-blizzard landscape. (Photograph by Eric Pence.)

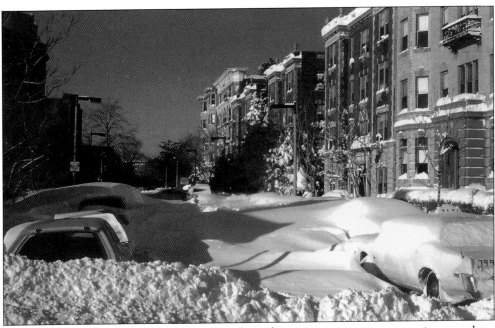

Buried cars and a Fenway street with three feet of snow meant no one was going anywhere anytime soon. (Photograph by Eric Pence.)

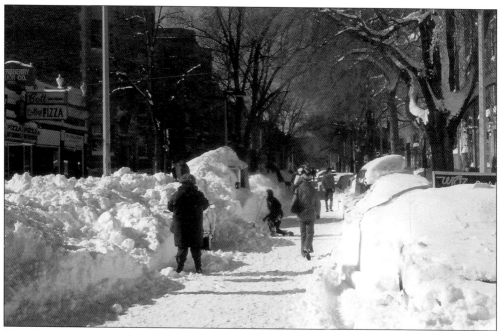

Some larger streets were at least plowed sufficiently to allow pedestrians and emergency vehicles to pass. (Photograph by Eric Pence.)

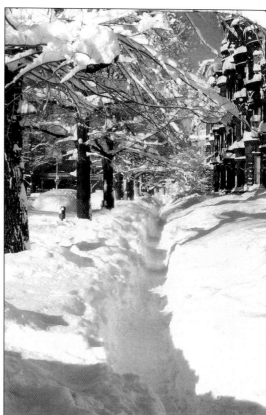

Sidewalks, cleared by hand in most cases, were another story; they were barely wide enough for one person, necessitating negotiations when two people met heading in opposite directions. (Photograph by Eric Pence.)

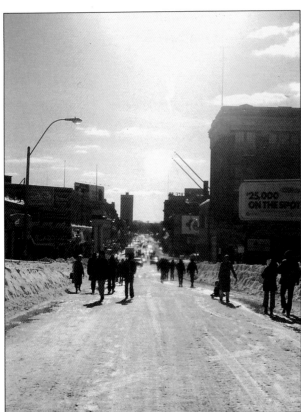

Pedestrians, some towing children on sleds, dominated this Boston roadway, leaving cars to pick their way cautiously toward their destination. (Photograph by Eric Pence.)

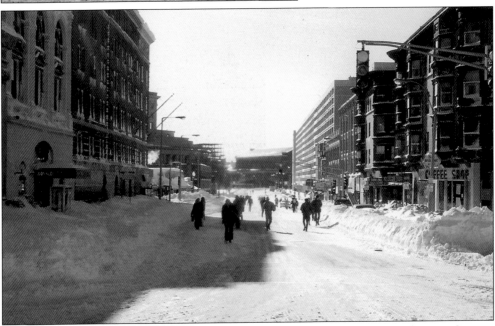

Massachusetts Avenue in Boston, with Symphony Hall straight ahead and the Christian Science Publishing building to the left, was also a pedestrian-friendly experience. (Photograph by Eric Pence.)

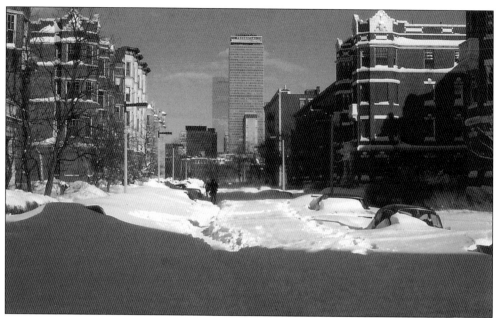

In the background, Boston's two tallest structures, the Prudential Building and John Hancock Tower, look down on a snow-clogged Fenway street. (Photograph by Eric Pence.)

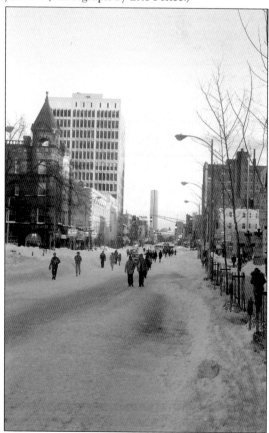

Looking southward through Central Square in Cambridge the endless parade of pedestrians and handful of motor vehicles extends to the distant dome of MIT. Beyond is Boston's Hancock Tower. (Photograph by Eric Pence.)

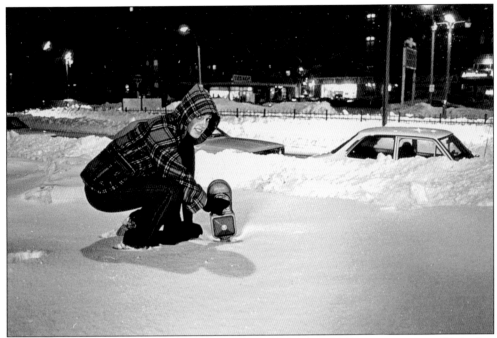

Towering over the parking meter, thanks to the deep, hard-packed snow, it seems unlikely that this young woman is too concerned about meter maids. (Photograph by Ken Glass.)

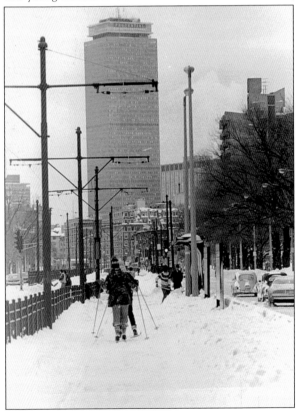

With Green Line service suspended, cross-country skiers also took over the tracks along Commonwealth Avenue, near Boston University (BU). (Photograph by Ken Glass.)

This skier is heading east in front of BU's Warren Towers. (Photograph by Ken Glass.)

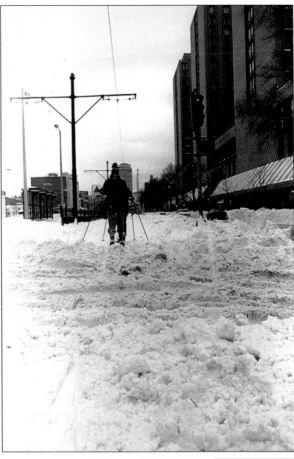

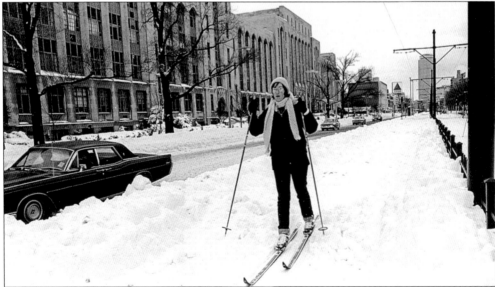

Some cars are back in operation in this photograph, but this skier still has the tracks—trolley tracks—to herself. (Photograph by Ken Glass.)

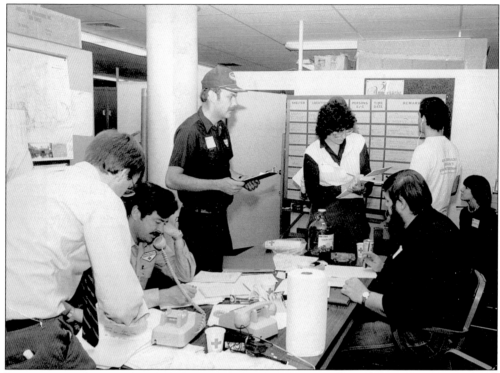

Emergency workers in this Red Cross operations center coordinated a variety of activities. (Photograph courtesy of American Red Cross Boston Chapter.)

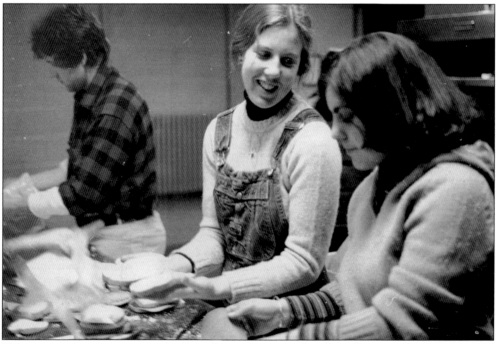

Volunteers are preparing sandwiches for evacuees and aid workers in this photograph. (Photograph courtesy of American Red Cross Boston Chapter.)

Particularly in some of the most hard-hit communities, the Red Cross provided shelter for families and individuals in the wake of the storm. (Photograph courtesy of American Red Cross Boston Chapter.)

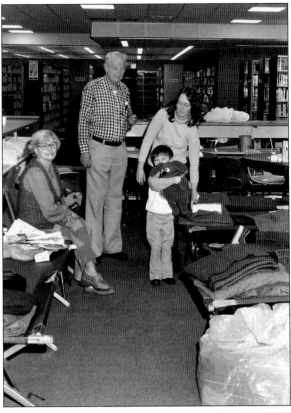

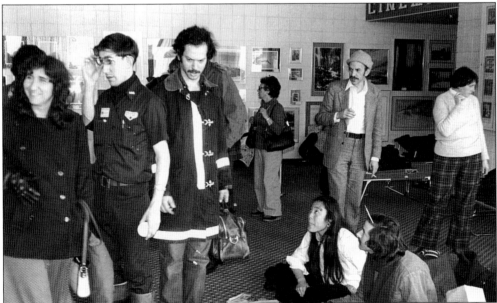

Hundreds of moviegoers unable to get out of the parking lot of the Dedham Showcase Cinema, as well as some drivers whose cars were stuck on nearby Route 128, found themselves staying longer than planned—up to two days. (Photograph courtesy of American Red Cross Boston Chapter.)

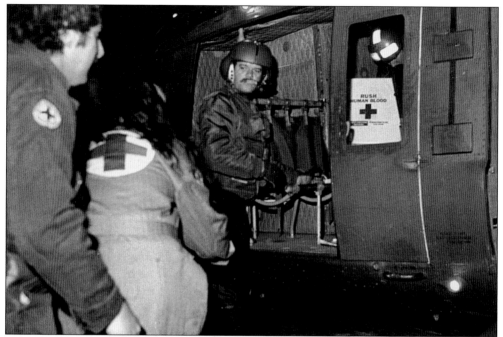

The National Guard helped support Red Cross emergency missions, in this instance transporting blood by helicopter. (Photograph courtesy of American Red Cross Boston Chapter.)

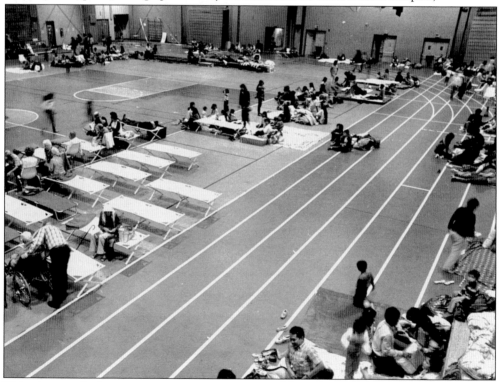

This photograph shows an emergency center at an athletic facility operated by the Red Cross during the blizzard. (Photograph courtesy of American Red Cross Boston Chapter.)

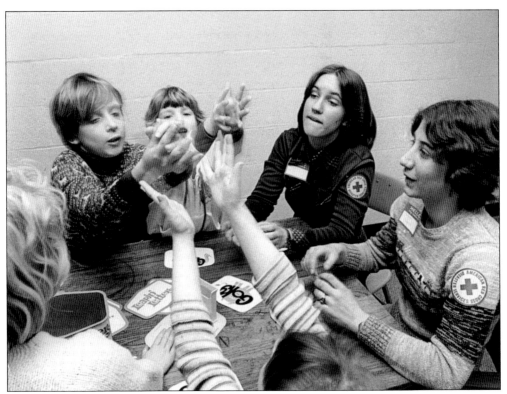

Volunteers provided fun and games for kids stuck in shelters during the storm. (Photograph courtesy of American Red Cross Boston Chapter.)

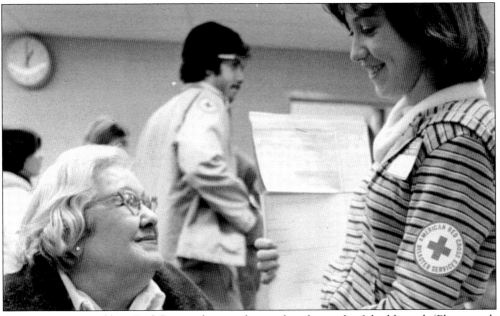

A woman is assisted by a Red Cross volunteer during the aftermath of the blizzard. (Photograph courtesy of American Red Cross Boston Chapter.)

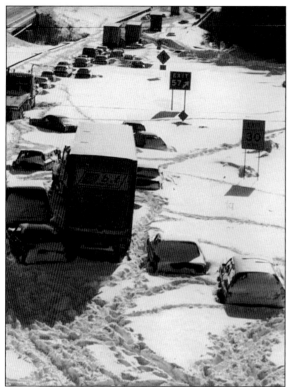

Stranded cars and trucks were a familiar sight, particularly along Route 128. This image shows exit 57 at Great Plain Avenue near Dedham and West Roxbury. (Photograph courtesy of American Red Cross Boston Chapter.)

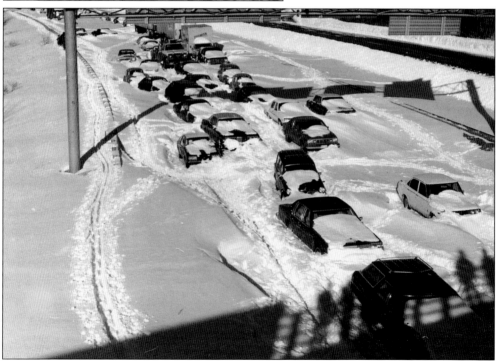

Many people spent the night in these unplanned car parks, and a few died, usually from carbon monoxide poisoning. (Photograph courtesy of U.S. Army Corps of Engineers.)

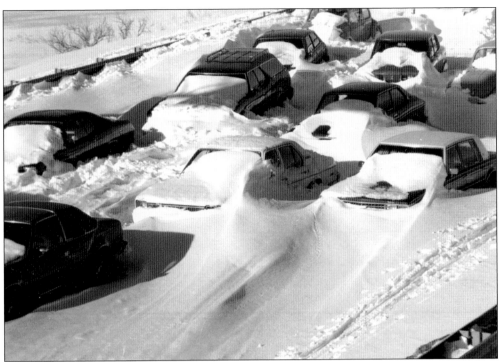

Cars, cars, and more cars littered Route 128, thousands in fact. (Photograph courtesy of U.S. Army Corps of Engineers.)

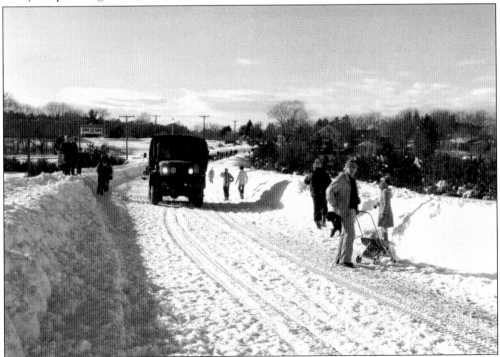

It took the arrival of army units to begin the process of cleaning up Route 128 and nearby areas. (Photograph courtesy of U.S. Army Corps of Engineers.)

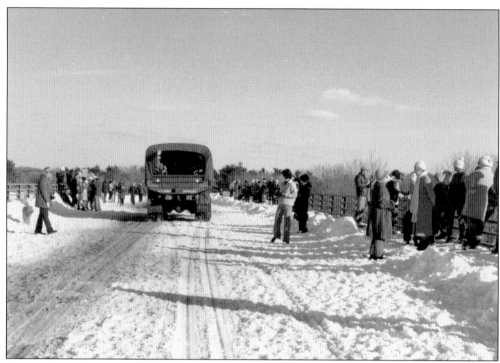

Army units and curious spectators cram this Route 128 overpass. (Photograph courtesy of U.S. Army Corps of Engineers.)

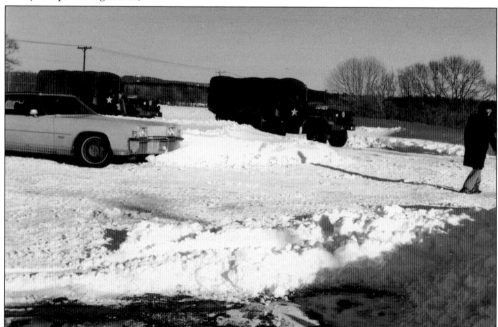

The Oldsmobile Toronado in the foreground was one of the few front-wheel drive cars available and in widespread use at the time of the blizzard. Most rear-drive vehicles were unable to cope with even modest snowfalls, let alone the deep snow produced by the blizzard. (Photograph courtesy of U.S. Army Corps of Engineers.)

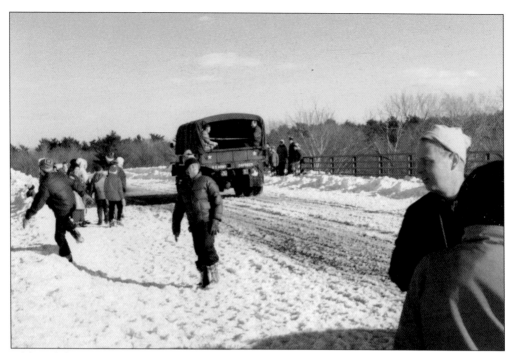

Although local armories often provided the first contingent of reservists, in some cases regular army units came in from as far away as Fort Bragg. (Photograph courtesy of U.S. Army Corps of Engineers.)

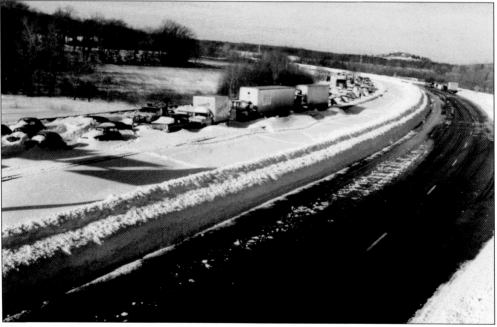

The army's cleanup method was to find areas of the roadway that were less clogged, clean them of snow, and then remove guard rails to the opposite side of the roadway and begin towing away stranded vehicles and carting away the remaining snow. (Photograph courtesy of U.S. Army Corps of Engineers.)

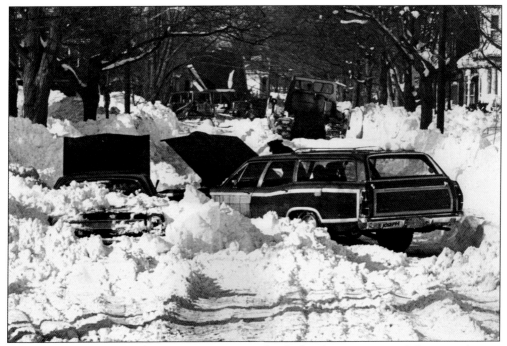

As if digging cars out of the snow was not enough of a burden, many cars did not much care to start in the cold, damp, post-blizzard conditions. (Photograph courtesy of U.S. Army Corps of Engineers.)

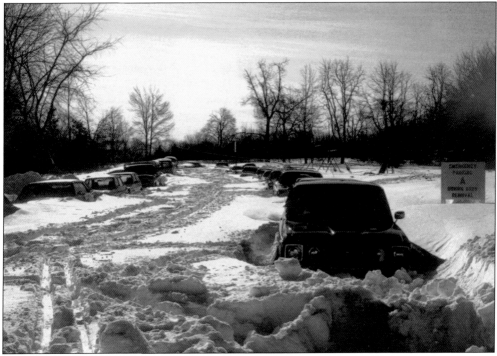

These vehicles were deeply snowed in near Hanscom Air Force Base. (Photograph courtesy of U.S. Air Force.)

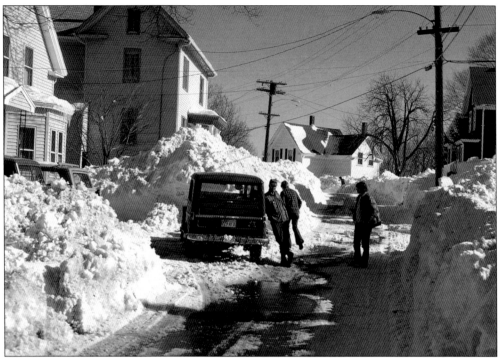

Bates Avenue in Quincy is mostly cleared of snow in this view, but this vintage jeep seems to be in trouble. (Photograph courtesy of Tom Bonomi.)

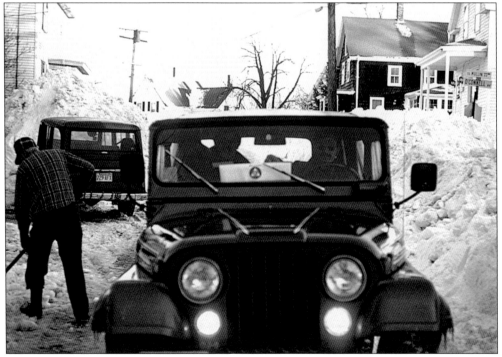

In a second image, chains on the older jeep appear to have been attached to the rear of the newer jeep with the Civil Defense tag on the windshield. (Photograph courtesy of Tom Bonomi.)

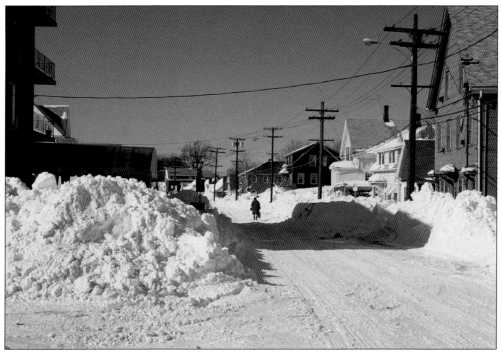

Although clear of snow, a pedestrian is the only traffic on Copeland Street in Quincy. (Photograph courtesy of Tom Bonomi.)

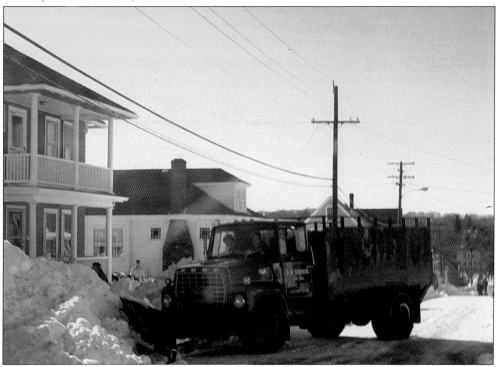

A plow tackles a snow drift in this photograph from South Quincy. (Photograph courtesy of Tom Bonomi.)

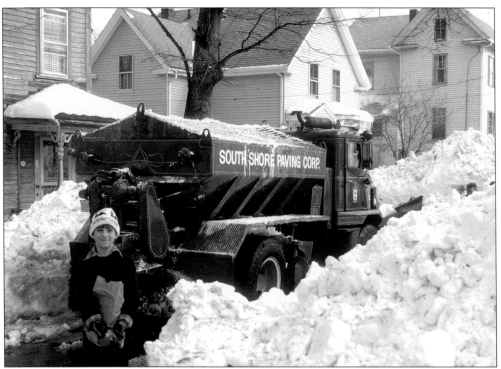

A boy identified as Georgi seems to be pleased that the plow has found his Quincy neighborhood. (Photograph courtesy of Tom Bonomi.)

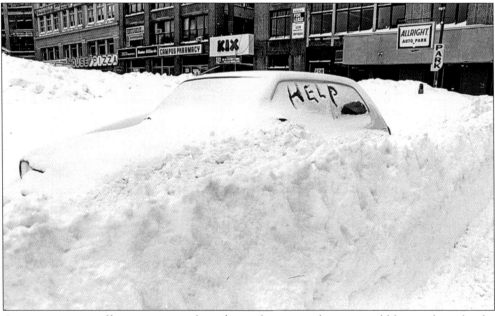

An anonymous graffiti artist, using the palette of snow on this car, could be speaking for the whole region. (Photograph by Ken Glass.)

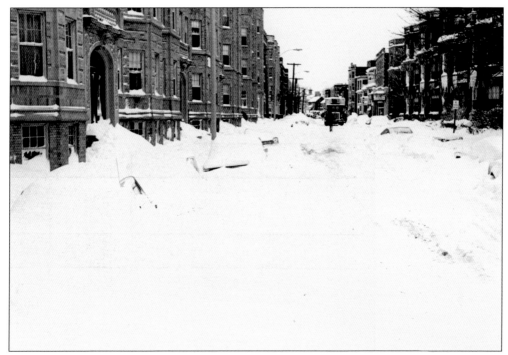

A food delivery truck attempts to pick its way along a snowy Boston street. (Photograph by Frank Florianz.)

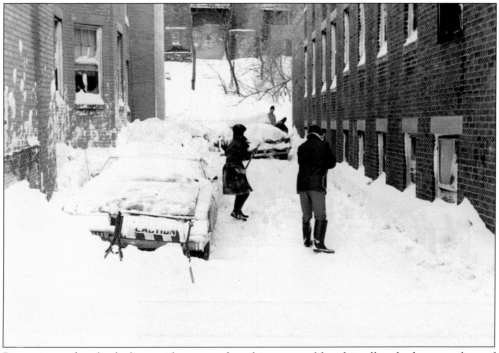

Bostonians, already dealing with cramped parking areas like this alley, had to use lots of muscle power and ingenuity to deal with the blizzard's output of snow. (Photograph by Frank Florianz.)

Drifting snow has almost blotted out the garage entrance at 25 Agawam Road in the Merrymount section of Quincy. (Photograph courtesy of Henry Nilsen.)

Another view of 25 Agawam Road clearly shows the depth of snow. (Photograph courtesy of Henry Nilsen.)

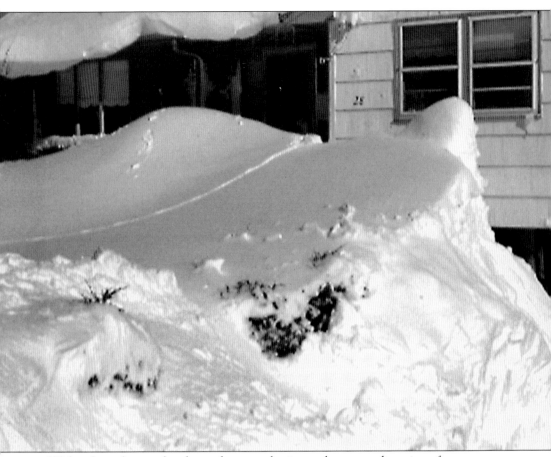

With a foot of snow already on the ground prior to the storm, disposing of more was no easy task. For the Watson family in Milton, reading, and watching TV filled up the time not spent shoveling. (Photograph by George S. Watson.)

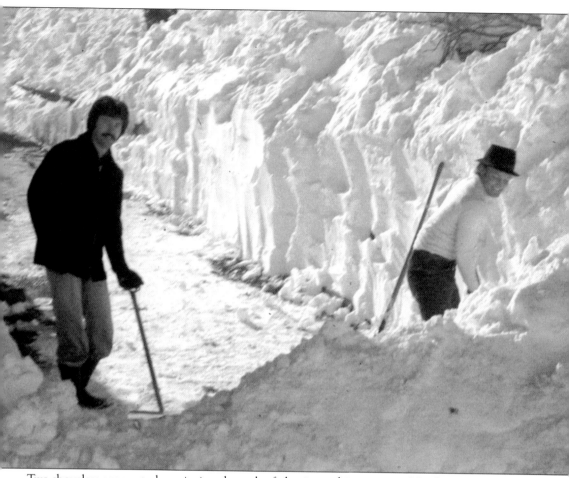

Two shovelers appear to be enjoying the task of clearing a driveway near North Easton center. (Photograph by Jonathan L. Rolfe.)

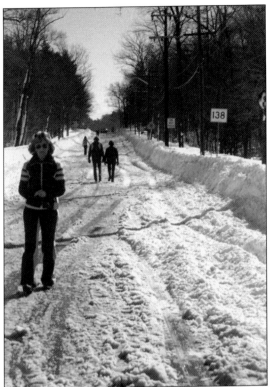

Pedestrians took over normally busy Route 138 in Easton in the days following the storm. (Photograph by Jonathan L. Rolfe.)

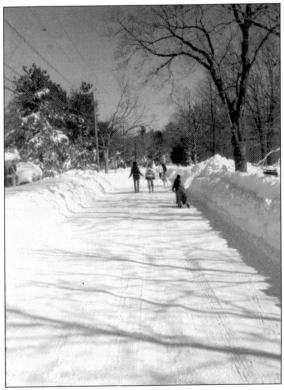

Lincoln Street in Easton also became a parade ground for pedestrians, some of whom hauled groceries on sleds. (Photograph by Jonathan L. Rolfe.)

Many recalled that neighbors made a point of helping neighbors and sharing supplies during the aftermath of the blizzard. Here walkers are seen along the road to North Easton center. (Photograph by Jonathan L. Rolfe.)

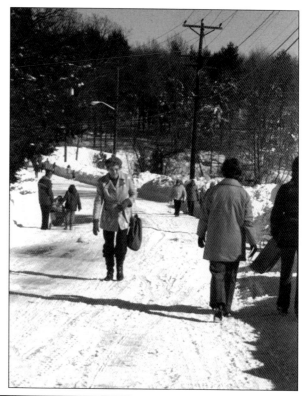

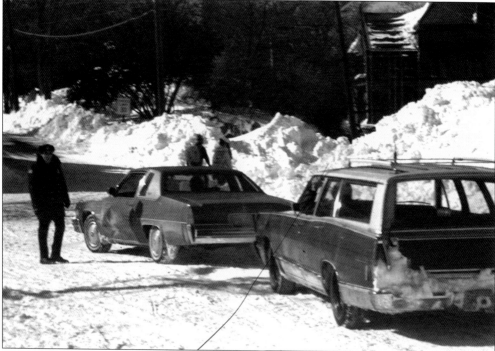

In this image of North Easton center, police were probably trying to ascertain whether the drivers had a legitimate reason for being on the road. (Photograph by Jonathan L. Rolfe.)

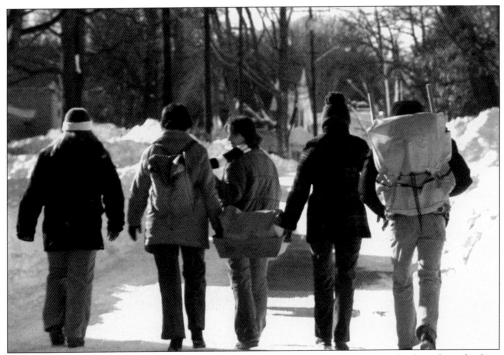

Normally automobile-dependent people had to adapt—in this case using a backpack and a box carried between two people to bring home groceries. (Photograph by Jonathan L. Rolfe.)

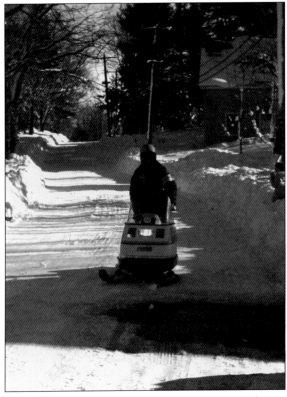

The lucky few had snowmobiles and could make the most of empty roads, in this case in North Easton. (Photograph by Jonathan L. Rolfe.)

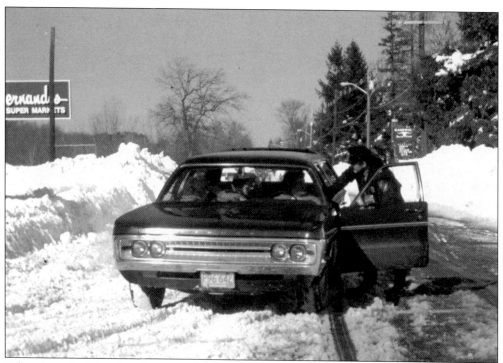

Police heard all kinds of excuses for people being out and about. Here a car has gotten tantalizingly close to a Fernandes Super Market, which is probably still closed. (Photograph by Jonathan L. Rolfe.)

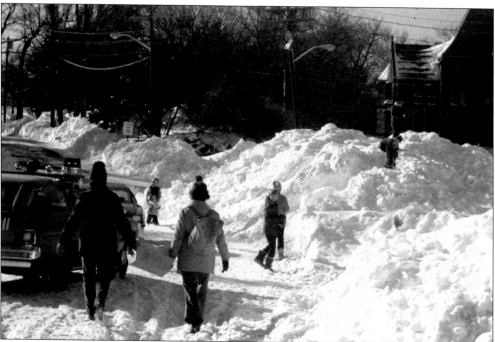

In this photograph of North Easton, emergency vehicles and pedestrians can be seen in the foreground. The Rockery is straight ahead, and the Oakes Ames Memorial Hall is to the right.

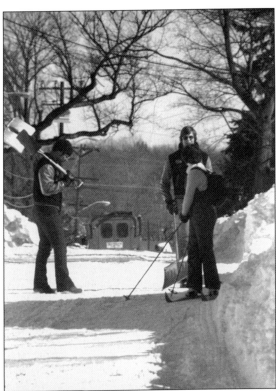

Shovels and skis were the most useful possessions in the days following the blizzard. (Photograph by Jonathan L. Rolfe.)

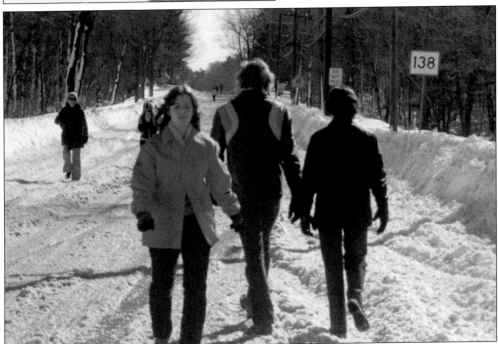

Even more pedestrians are finding their way home, or to shopping, in this photograph of Route 138. Many people ended up walking across large sections of eastern Massachusetts to visit friends or return to homes. (Photograph by Jonathan L. Rolfe.)

Two women share the task of carrying supplies in this photograph. (Photograph by Jonathan L. Rolfe.)

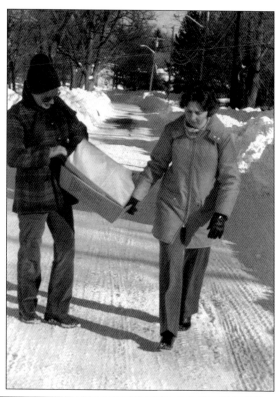

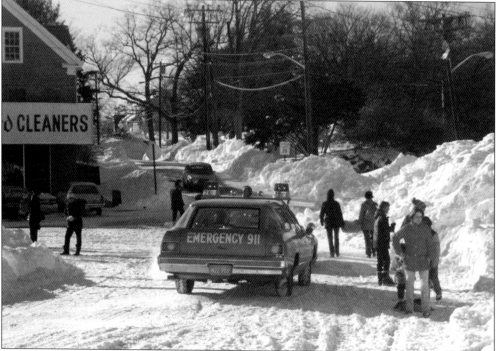

A knot of pedestrians and a few cars defines North Easton center in this photograph. (Photograph by Jonathan L. Rolfe.)

Inevitably supply trips turned into social occasions and an opportunity to meet neighbors and discuss the weather. (Photograph by Jonathan L. Rolfe.)

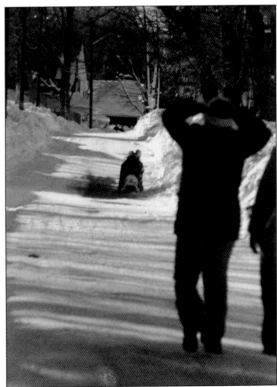

A snowmobile has just passed a group of Easton pedestrians in this photograph. (Photograph by Jonathan L. Rolfe.)

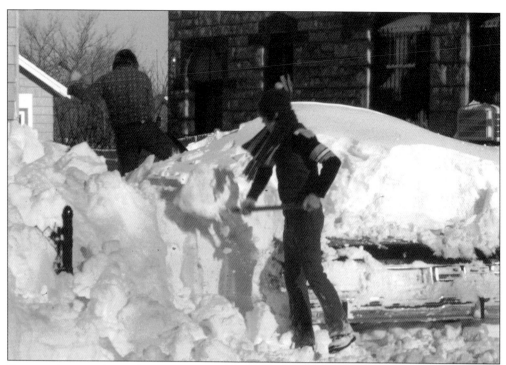

Two people are trying to dig out a car near North Easton center in this photograph. (Photograph by Jonathan L. Rolfe.)

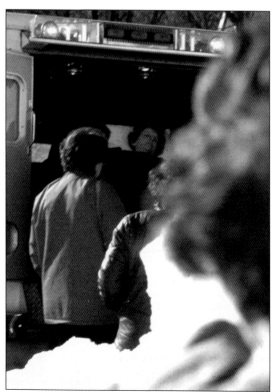

For emergency workers, life had to go on. Here crews have made it through the snow to assist an unidentified woman in North Easton. (Photograph by Jonathan L. Rolfe.)

The Jabs family of Oxbow Road in Wayland already had snow up to their windowsills from a previous storm, as shown in this photograph. When the blizzard struck, it sealed off some windows almost entirely. (Photograph courtesy of Lillian Jabs.)

The bottom half of this window has been completely covered by snow. (Photograph courtesy of Lillian Jabs.)

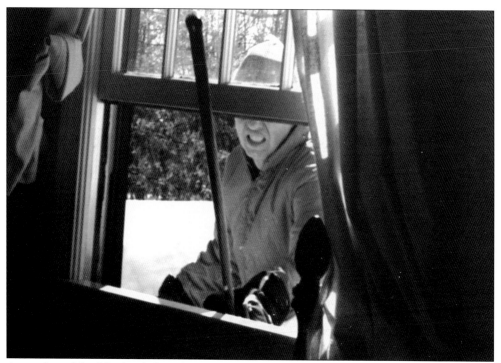

A member of the Jabs family has cleared snow down to the level of the windowsill. (Photograph courtesy of Lillian Jabs.)

Just to prove a point, the shoveler shown above has climbed from the snow directly into the house. (Photograph courtesy of Lillian Jabs.)

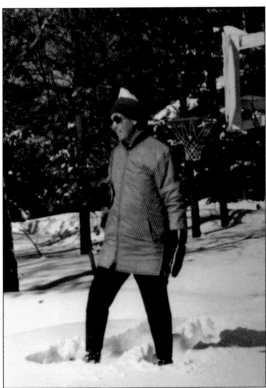

Drifting snow puts a basketball hoop at shoulder height for this member of the Jabs family. (Photograph courtesy of Lillian Jabs.)

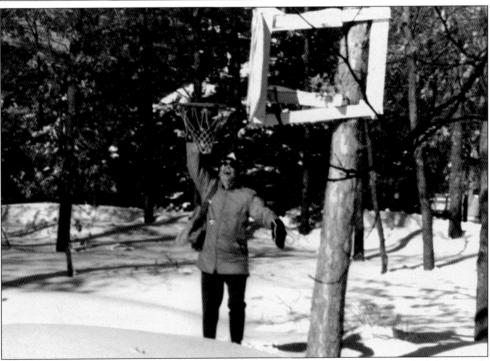

Even without the boost provided by the snowdrift, it is still easy to get a slam-dunk. (Photograph courtesy of Lillian Jabs.)

Where's the driver? Deep snow has hidden him and the rest of this snow-removal vehicle. (Photograph courtesy of Lillian Jabs.)

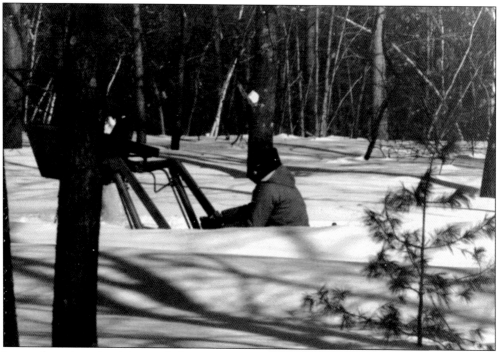

In another view, the driver and the tractor are still nearly hidden from view, and the bucket scarcely has enough reach to deposit snow above the mean depth achieved by the storm. (Photograph courtesy of Lillian Jabs.)

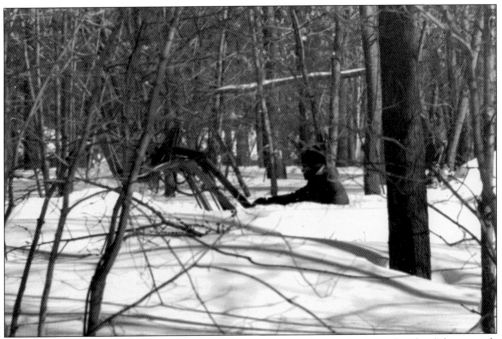

Even with mechanical help, digging out was no easy task for the Jabs family. (Photograph courtesy of Lillian Jabs.)

As a last resort, the shovel and muscle must finish the job. (Photograph courtesy of Lillian Jabs.)

Finally, shovels and plows have provided a way out of the neighborhood for the Jabs family, but non-emergency vehicles were still not welcome on Wayland town streets. (Photograph courtesy of Lillian Jabs.)

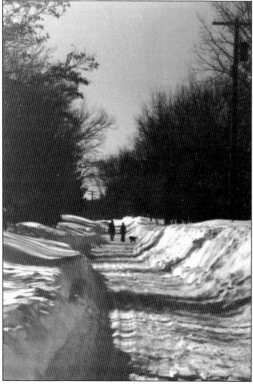

Lillian and Walter Jabs and the family dog take a walk along Oxbow Road. (Photograph courtesy of Lillian Jabs.)

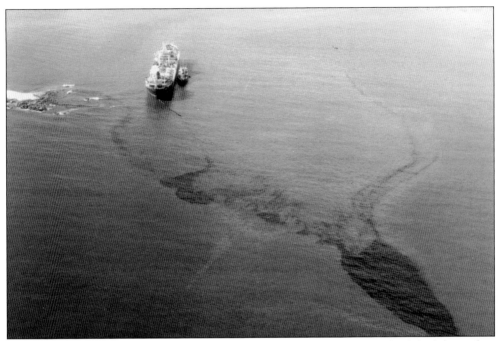

There was recovery going on at sea, too. Here the *Global Hope*, a tanker which had dragged its anchors, ended up on the rocks in Salem Sound. A small oil slick is also visible. (Photograph courtesy of U.S. Army Corps of Engineers.)

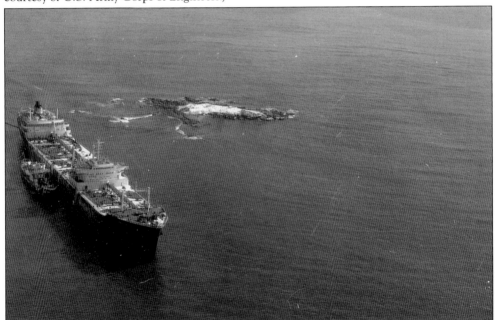

A U.S. Coast Guard vessel can be seen moored to the starboard side of the *Global Hope* in this photograph. The effort to reach and rescue the ship during the storm cost men their lives. When one of the Coast Guard's 44-foot motor lifeboats was damaged and had to turn back, Frank Quirk, captain of the pilot boat *Can Do*, tried to get to the *Global Hope*. He and his crew did not survive. (Photograph courtesy of U.S. Army Corps of Engineers.)

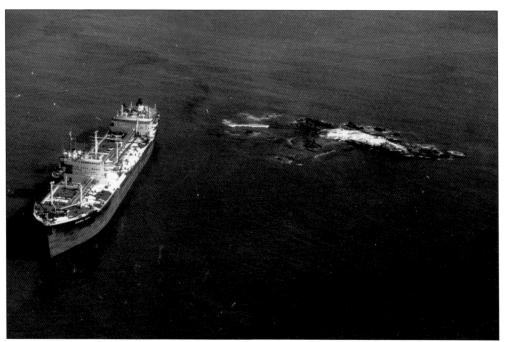

Another aerial view of the *Global Hope* shows clearly how close the ship came to being broken up on the rocks and causing an even more serious environmental situation. (Photograph courtesy of U.S. Army Corps of Engineers.)

The memorial to another 44-foot lifeboat that was lost in rough water off the Columbia River in the 1990s gives a small hint of the challenges faced by rescuers and carefully detailed by author Michael Tougias in *Ten Hours Until Dawn: The True Story Of Heroism And Tragedy Aboard The Can Do.* (Photograph courtesy of U.S. Coast Guard.)

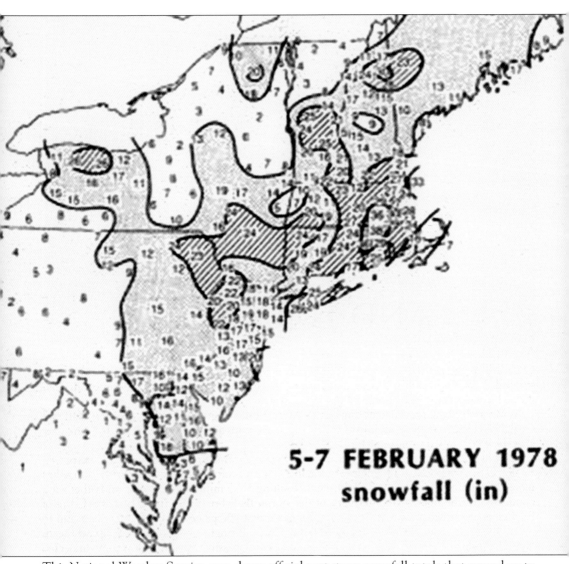

5-7 FEBRUARY 1978
snowfall (in)

This National Weather Service map shows official post-storm snowfall totals that ranged up to 38 inches for some areas south of Boston. Anecdotal evidence suggests depths just as great in other areas too. (Photograph courtesy of the National Weather Service.)

Three

DIGGING OUT AND RECOVERY

Cleaning up and getting the state back to normal began in earnest almost as soon as the snow stopped. It was no small task. For many areas, digging out was a weeks-long process. Indeed normalcy never returned in some places.

In Massachusetts, the Federal Emergency Management Agency (FEMA) gave the National Guard and U.S. Army responsibility for clearing major roads and highways of snow and removing abandoned or stalled vehicles.

Most of the equipment needed came from private contractors within the state. According to the U.S. Army Corps of Engineers, small business and minority owned firms, altogether more than 2,300 of them, received payments totaling $14.5 million for plowing and other work conducted in the immediate aftermath of the storm. By February 12, the U.S. Army Corps of Engineers had inked almost 400 contracts for the use of 900 pieces of heavy equipment. But to meet all the needs in the state, the U.S. Army Corps of Engineers also hired equipment from New Hampshire, Vermont, and New York. In some cases, passing equipment was commandeered on the spot, with compensation arranged later.

Equal in its impact on recovery with the storm itself was the State of Emergency Executive Order issued by Gov. Michael S. Dukakis, which mandated the closing of most businesses and the banning of non-essential vehicle traffic. It also converted February 7 through 12, 1978, into temporary legal holidays and, thanks to the governor's power of persuasion, paid legal holidays for many workers. Exceptions were made for banks, pharmacies, food stores, heating oil and utility companies and, of course, health care facilities. Employees of these establishments were necessarily exempted from the driving ban, though in many cases it hardly mattered since many roads remained impassable.

Those violating the travel ban came up with a wide range of excuses. Cabin fever was one. Jack Mileski, at the time an employee of Digital Equipment Corporation, found himself drawn back to the office in the "Mill" at Maynard after a few days of enforced leisure and made the trip from a nearby town without getting stopped. He was amazed to find the vast building entirely empty—except for company founder Ken Olsen, who apparently was similarly affected by the disruption to his schedule.

Police enforcement varied from sympathetic to draconian. One representative group of joy-riding North Shore teens got away with telling the police who were enforcing the driving ban

that they were taking food to their grandmothers. On the other end of the spectrum, Governor Dukakis tells a story, perhaps apocryphal, of a cabin fever sufferer who was stopped on his way to his office in Boston by military police on Interstate 93. The military police scolded him, impounded his car, and sent him to walk home with a note in his pocket stating, "this man is insane."

Then there was the necessity of relaxing a range of state laws regarding construction permits in order to provide for immediate emergency repairs. The governor's executive order also offered this while requiring that the work done, on such a basis, was the "minimum amount necessary to protect the endangered structure or property and abate the emergency."

Two other important provisions rounded out the gubernatorial response. As the travel ban was relaxed, buses and other public passenger vehicles were made temporarily exempt from any statute or regulation governing routes, schedules, and other operational details—a tacit admission that many roads would still not be serviceable. Likewise employers were requested to establish staggered work hours to allow the state to gradually return to full function with the minimum number of traffic jams and commuter delays.

In the weeks that followed, nature did not make things easier. There were other snow falls in a long, cold season. Giant mounds of snow remained as visible reminders of the great storm long into spring.

And, ever after, for a whole generation of New Englanders, there would always be that reliable conversation starter, "Where were you in the blizzard of '78?"

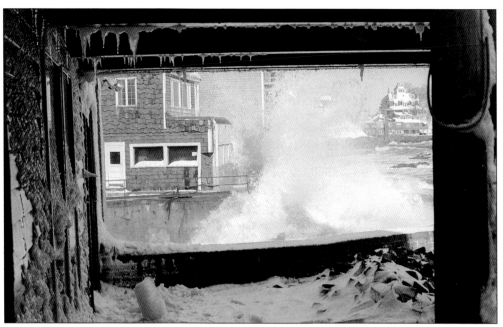

Icicles and more surf can be seen in this view of the Marblehead shore. (Photograph courtesy of Michael Shavelson.)

Marblehead's narrow streets were mobbed with pedestrians, while car travel was impermissible. (Photograph courtesy of Michael Shavelson.)

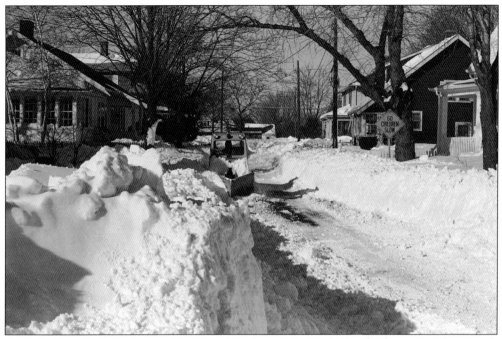

A small sidewalk plow tries to widen the plowed area of a Marblehead side street. (Photograph courtesy of Michael Shavelson.)

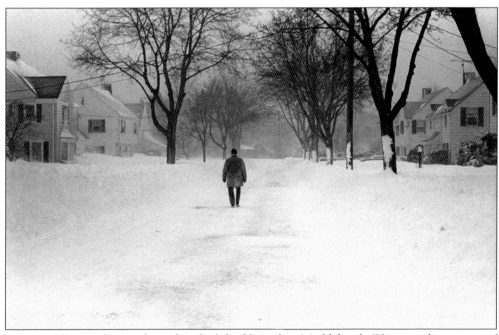

A lone pedestrian braves the tail end of the blizzard in Marblehead. (Photograph courtesy of Michael Shavelson.)

Surf crashes over a seawall in Marblehead. (Photograph courtesy of Michael Shavelson.)

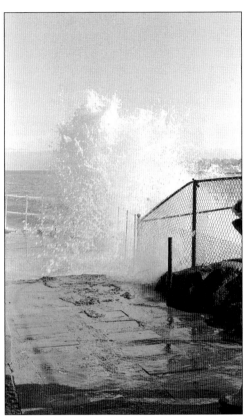

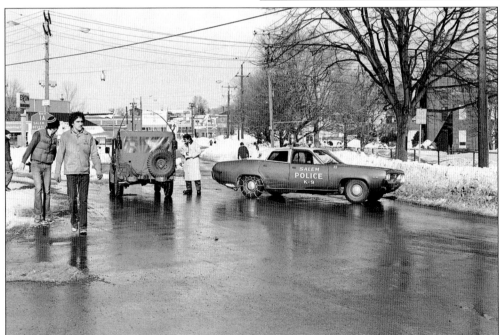

Salem police and army units are shown here at the town border with Marblehead. (Photograph courtesy of Michael Shavelson.)

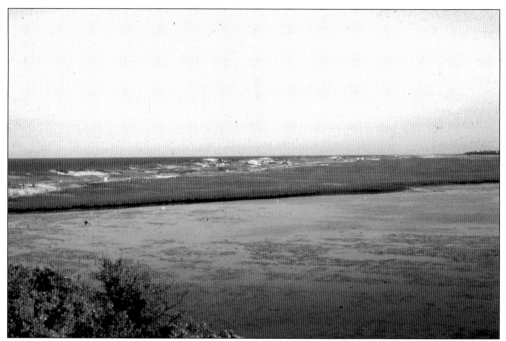

Further afield, Cape Cod underwent many dramatic changes during the blizzard. Here Coast Guard Beach in Eastham is pictured before the blizzard of 1978 in this photograph taken by Nan Turner Waldron (author of the book *Journey to Outermost House*). (Photograph courtesy of Henry Beston Society.)

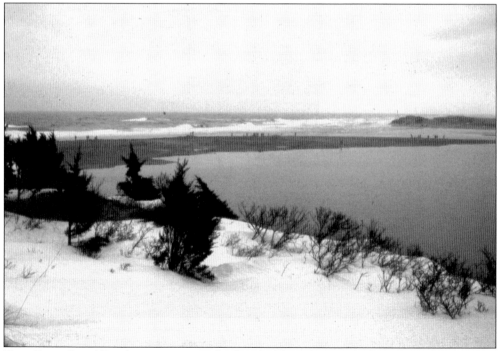

Here Coast Guard Beach is seen one week after the blizzard. Note the break in the beach. The photograph was taken by Waldron. (Photograph courtesy of Henry Beston Society.)

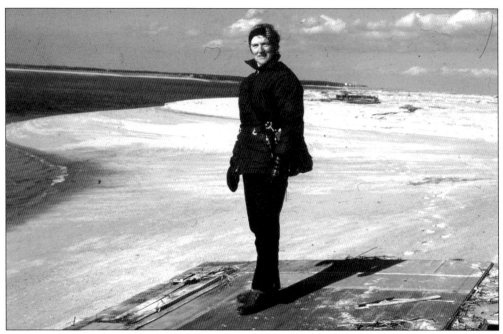

Waldron stands on what is left of the floor of Henry Beston's famous Outermost House on February 13, 1978. This photograph was provided by Waldron to the Henry Beston Society just prior to her death in November 2000. (Photograph courtesy of Henry Beston Society.)

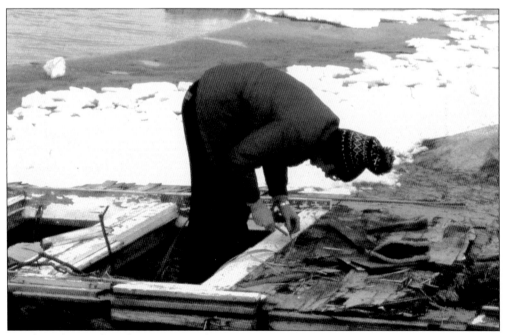

Beachcombers gathered up pieces of what was left of Henry Beston's Outermost House at Coast Guard Beach in Eastham and Nauset Beach in Orleans one week after the blizzard of 1978. This photograph by Waldron was provided to the Henry Beston Society. (Photograph courtesy of Henry Beston Society.)

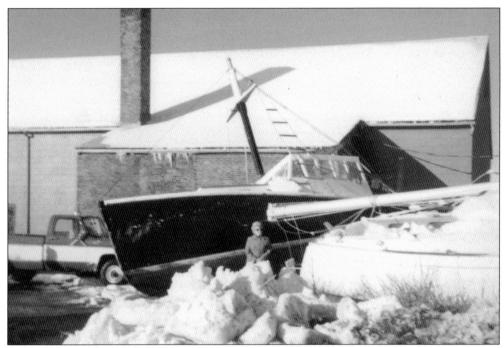

The harbor and coast of Scituate suffered severe devastation, as well as loss of life as shown in these images snapped by then assistant harbormaster Elmer Pooler. (Photograph courtesy of Elmer Pooler.)

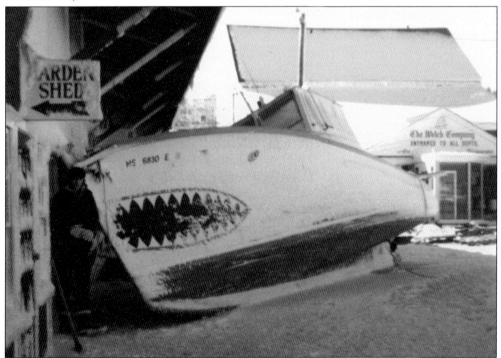

This photograph shows another of the many boats driven ashore in the blizzard. (Photograph courtesy of Elmer Pooler.)

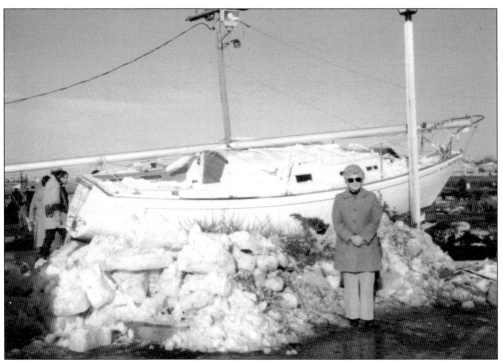

In this photograph, the victim is a sailboat rather than a commercial craft. (Photograph courtesy of Elmer Pooler.)

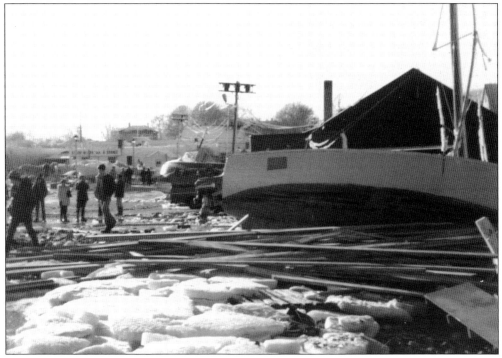

Crowds came out to assess the damage, as well as look for those still missing in the storm. (Photograph courtesy of Elmer Pooler.)

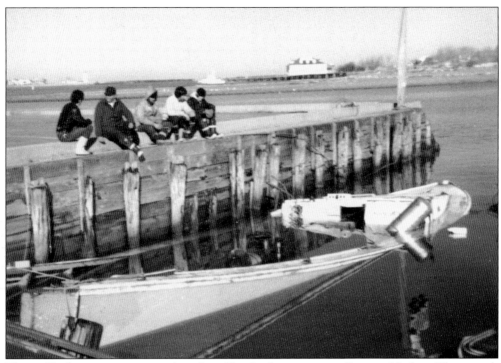

This sad-looking group seems to be sobered by the devastation in Scituate Harbor. (Photograph courtesy of Elmer Pooler.)

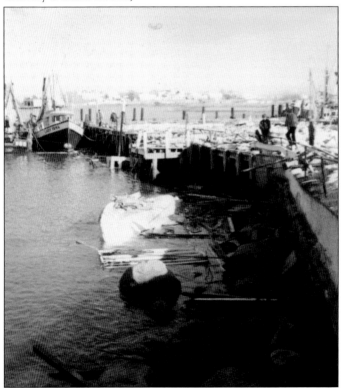

Debris was everywhere, both ashore and afloat. It was so bad that in one instance, a storm victim was not discovered until April, when more of the flotsam and jetsam were finally removed. (Photograph courtesy of Elmer Pooler.)

Undaunted by the storm's devastation, Elmer Pooler reports that the young man in the foreground grew up to become a commercial fisherman. (Photograph courtesy of Elmer Pooler.)

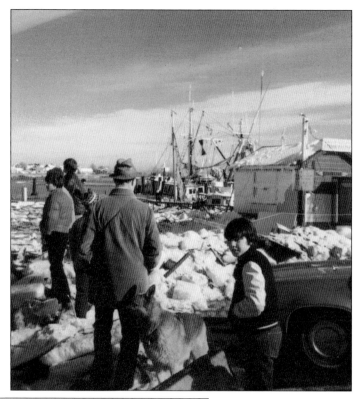

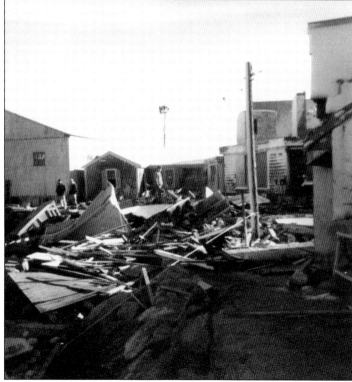

Facing a 17.5-foot tidal surge, the Coast Guard had sent a 44-foot motor lifeboat to assist mariners in Scituate (similar to the one that was unsuccessful in reaching the *Global Hope* in Salem). Between the waves and the ropes and debris in the harbor, the boat lost steering and was in danger of sinking on the rocks here behind T. K. O'Malley's. Pooler helped bring the Coast Guard members ashore, and later, after the storm, fishermen helped pull the damaged 44-footer back to sea. (Photograph courtesy of Elmer Pooler.)

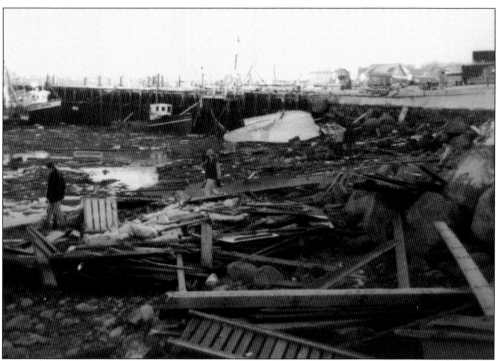

This additional photograph provides a bleak, post-storm panorama of the harbor. (Photograph courtesy of Elmer Pooler.)

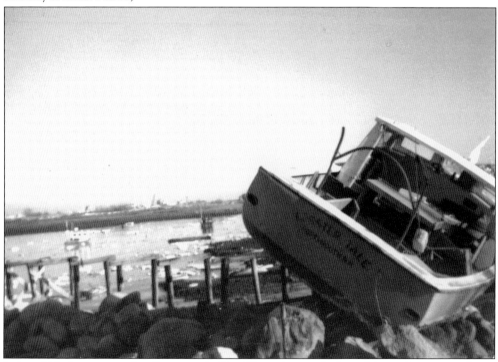

Lobster Tale, home ported to Portsmouth, New Hampshire, is high and dry and in no condition to go home in this photograph. (Photograph courtesy of Elmer Pooler.)

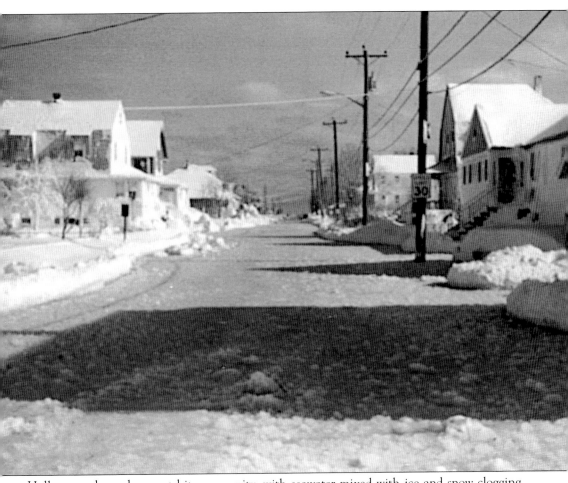

Hull was perhaps the worst hit community, with seawater mixed with ice and snow clogging roads and battering homes. A combination of snow and seawater fills A Street in Hull in this image, looking east. (Photograph courtesy of Bruce Simons.)

A car, barely visible, above the floodwaters, is in the distance behind the tree branches on Central Avenue in Hull. (Photograph courtesy of Bruce Simons.)

The moving, glacier-like snow and freezing seawater can be seen in this photograph of Central Avenue. (Photograph courtesy of Bruce Simons.)

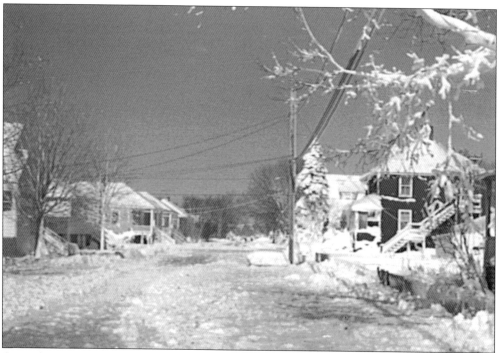

Central Avenue, looking toward the north, is pictured in this image. (Photograph courtesy of Bruce Simons.)

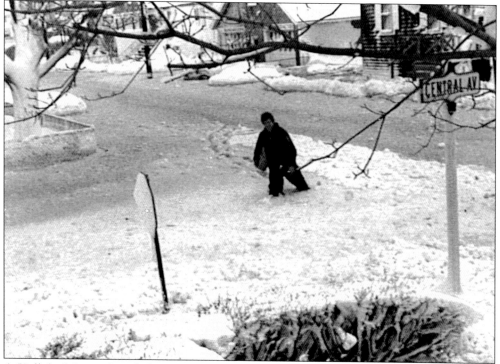

A Hull firefighter, identified as Ken Resnick, is seen slogging through across flooded Central Avenue. (Photograph courtesy of Bruce Simons.)

Hadassah Way in Hull, also flooded, is the subject of this snapshot. (Photograph courtesy of Rosalyn Simons.)

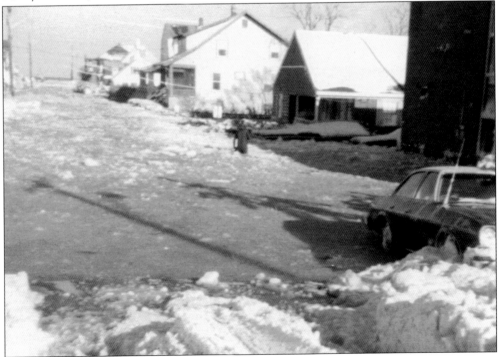

On Coburn Street in Hull, the photographer caught an unusually well-prepared man in a wet suit making his way down the flooded road. (Photograph courtesy of Rosalyn Simons.)

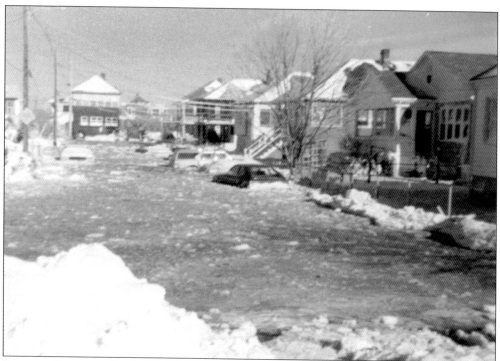

Brewster Street was also up to the hoods of the cars in seawater. (Photograph courtesy of Rosalyn Simons.)

Cars and basements were in tough shape on Hadassah Way. The photographer was among those evacuated by boat and paddy wagon and had to spend several days in an emergency shelter at the Memorial School. (Photograph courtesy of Rosalyn Simons.)

Two rivers of seawater come together at the intersection of A Street and Central Avenue in this photograph. (Photograph courtesy of Bruce Simons.)

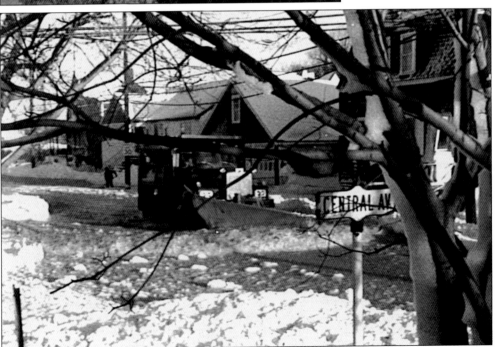

Rescue vehicles were a welcome site (a plow is shown here on A Street at Central Avenue) but due to the extensive damage to homes and infrastructure, it took far more to bring a return to normalcy. (Photograph courtesy of Bruce Simons.)

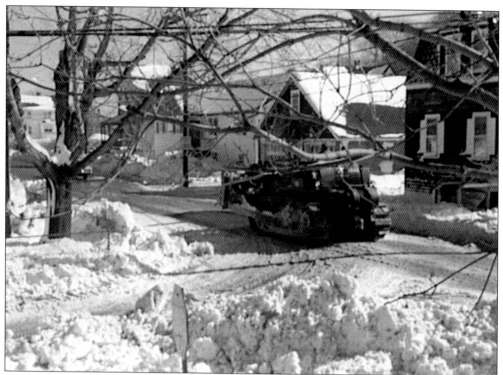

Here, an army bulldozer heads down A Street in Hull. (Photograph courtesy of Bruce Simons.)

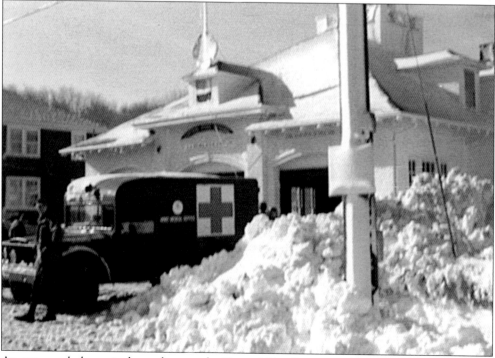

An army ambulance is shown here at the Central Fire Station on Nantasket Avenue in Hull. (Photograph courtesy of Bruce Simons.)

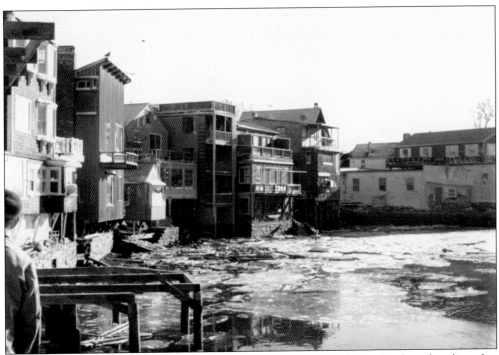

Destruction and debris were also in abundance along the Rockport Harbor shoreline. Joe Pelczarski, who worked at the state division of marine fisheries, was called in to help with assessing storm damage north of Boston. (Photograph by Joseph E. Pelczarski.)

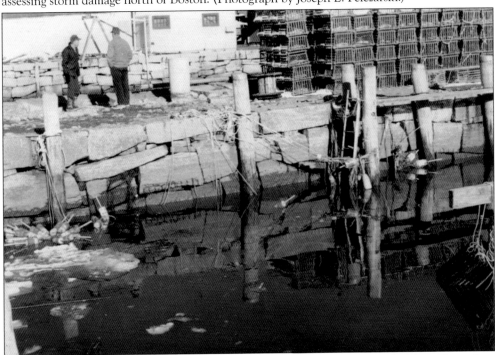

Although these wooden lobster pots had remained neatly stacked through the blizzard, much in the foreground is a tangled mess. (Photograph by Joseph E. Pelczarski.)

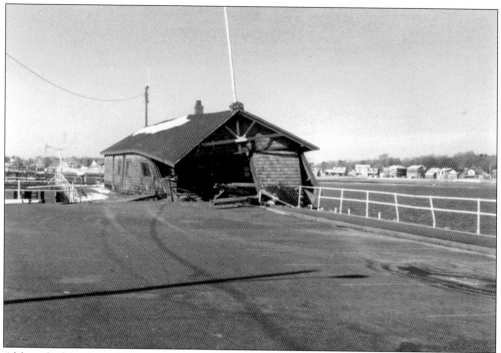

Although this pier in Nahant survived the blizzard, the structure on it did not. (Photograph by Joseph E. Pelczarski.)

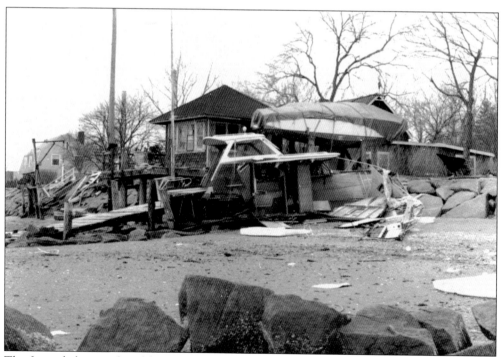

The Ipswich boatyard and boats in this photograph were shredded by the wind and waves. (Photograph by Joseph E. Pelczarski.)

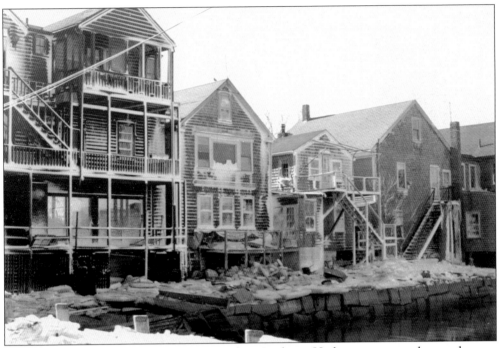

According to Joe Pelczarski, these buildings along Rockport Harbor were covered top-to-bottom with ice, evidence of the salt spray from the crashing waves and whipping winds. (Photograph by Joseph E. Pelczarski.)

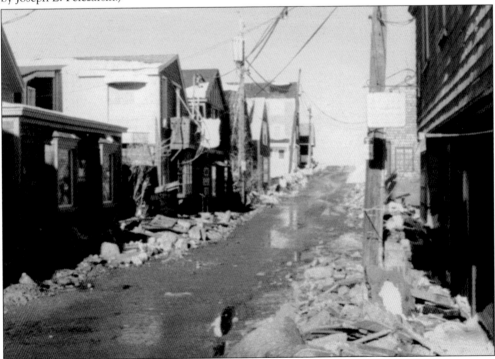

Picturesque Bearskin Neck in Rockport was covered in sand and debris thanks to the storm. (Photograph by Joseph E. Pelczarski.)

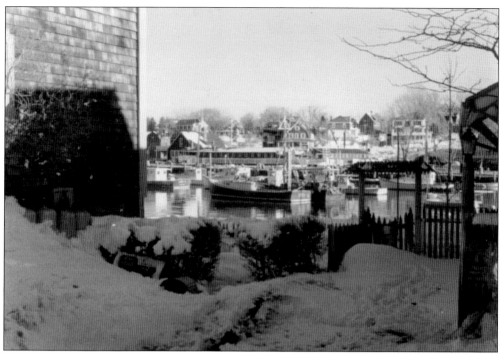
This is another post-storm view of Rockport Harbor. (Photograph by Joseph E. Pelczarski.)

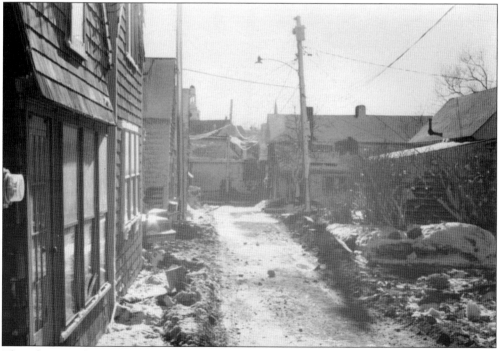
This photograph provides more evidence of the damage done to Bearskin Neck by wind and water. (Photograph by Joseph E. Pelczarski.)

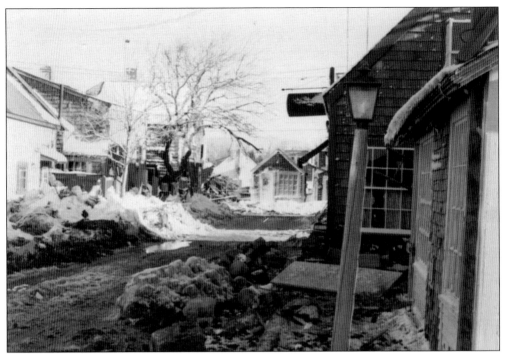

Bearskin Neck's narrow but normally well-traveled lanes have been obscured by misplaced boulders and others leavings of the storm. (Photograph by Joseph E. Pelczarski.)

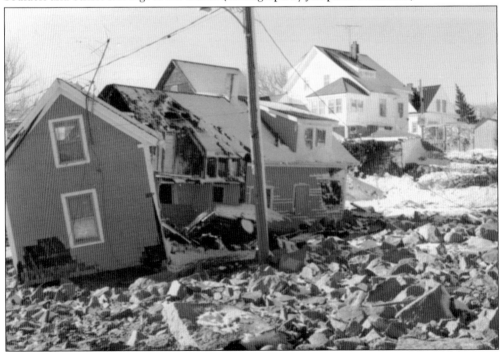

This house in Pigeon Cove, captured in one of Joseph Pelczarski's photographs, was split in half by the force of the storm surge and crashing waves. A full-size car is part of the debris field between the house and the utility pole. (Photograph by Joseph E. Pelczarski.)

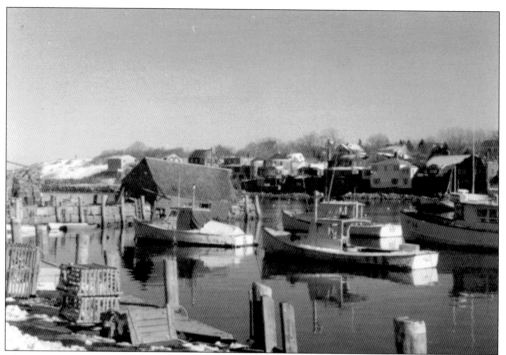

The remains of Motif No. 1—claimed by some to be the most painted scene in America—can be seen just beyond the boats in this image of Rockport Harbor. (Photograph by Joseph E. Pelczarski.)

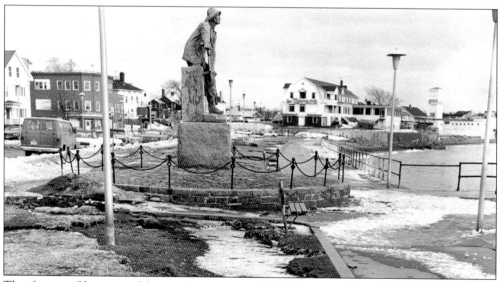

The famous Gloucester fisherman's statute survived the storm, but what he saw from his perch must have been disheartening even to such a seasoned mariner. (Photograph by Joseph E. Pelczarski.)

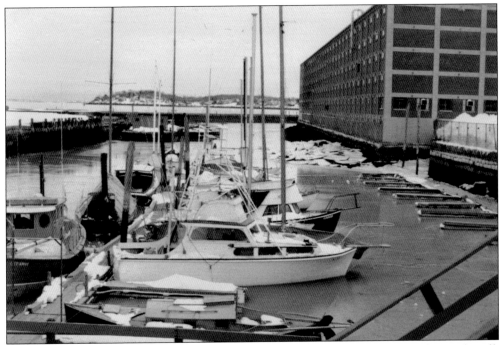

In addition to leaking oil from the *Global Hope* at the outer harbor, a chemical spill, origin unknown, contaminated this stretch of the South River in Salem. (Photograph by Joseph E. Pelczarski.)

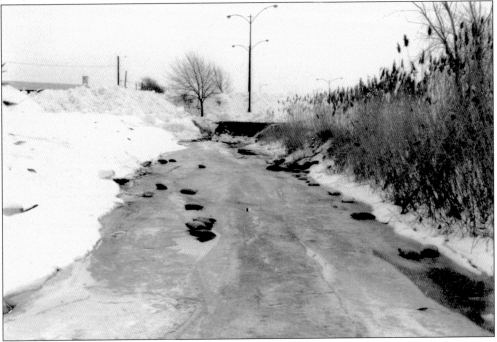

In another instance, according to Joseph Pelczarski, gasoline covered the shoreline in East Boston, near Suffolk Downs. The weight of the snow had collapsed the roof on a nearby gasoline storage tank, causing the spill. (Photograph by Joseph E. Pelczarski.)

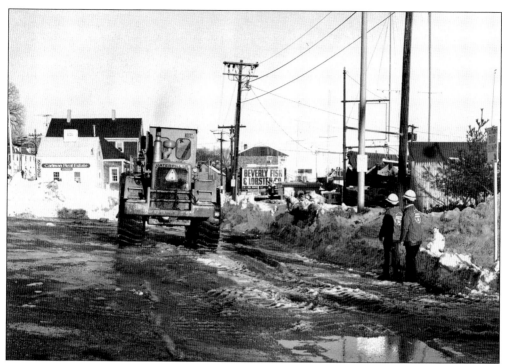

A front-end loader helps with cleanup work in Beverly. (Photograph courtesy of U.S. Army Corps of Engineers.)

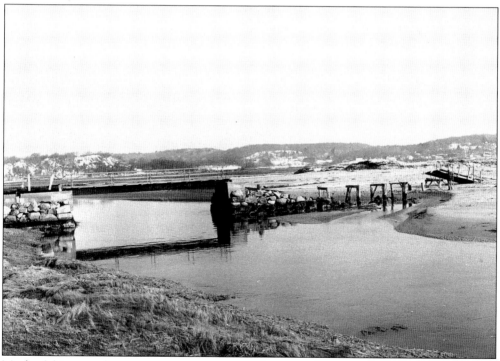

Much of this coastal causeway was swept away in the storm. (Photograph courtesy of U.S. Army Corps of Engineers.)

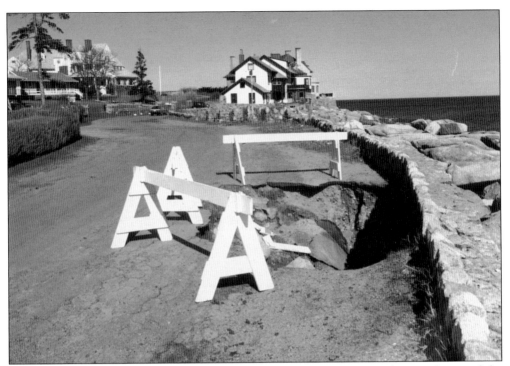

Here a sinkhole has appeared in a coastal roadway where the ocean waves have undermined the underlying structure. (Photograph courtesy of U.S. Army Corps of Engineers.)

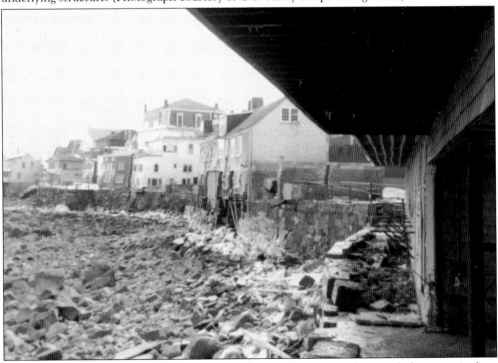

Jumbled rocks from collapsed structures and seawalls give evidence of the storm's fury. (Photograph courtesy of U.S. Army Corps of Engineers.)

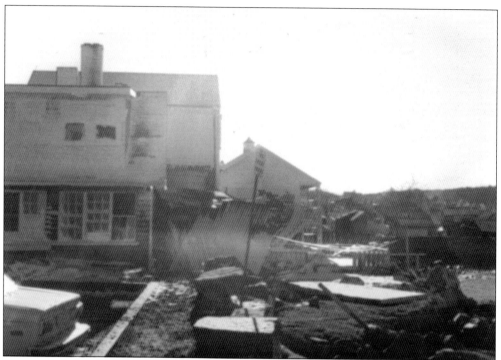

Here a deck has been torn from a harbor-front building and left elsewhere by the storm. (Photograph by Joseph E. Pelczarski.)

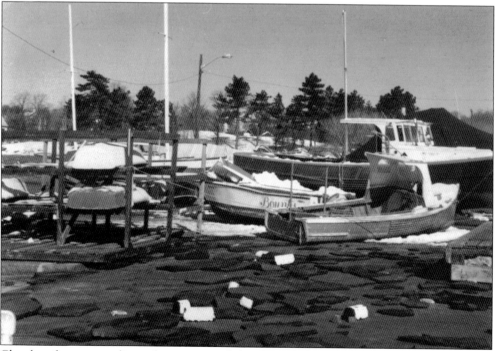

Chunks of pavement litter the remains of this Ipswich boatyard in the storm's aftermath. (Photograph by Joseph E. Pelczarski.)

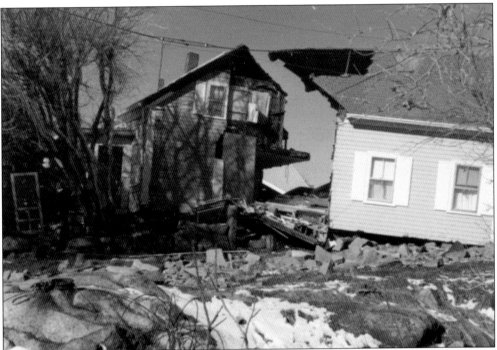

This house in Pigeon Cove, Rockport, was ripped in half by the waves. (Photograph by Joseph E. Pelczarski.)

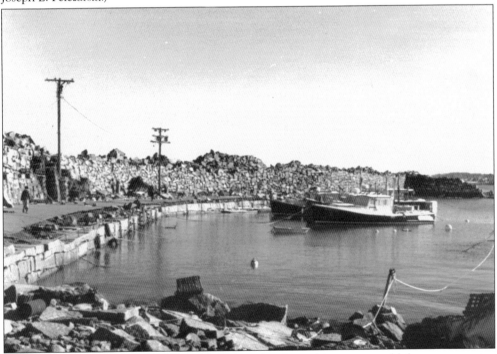

Eyewitnesses to the storm told Joseph Pelczarski that white caps could be seen coming over the top of the Pigeon Cove breakwater at the peak of the storm. (Photograph by Joseph E. Pelczarski.)

Along Pigeon Cove, Pelczarski found that the storm surge had left lobster shacks, other buildings, boats, and debris hundreds of feet inland. (Photograph by Joseph E. Pelczarski.)

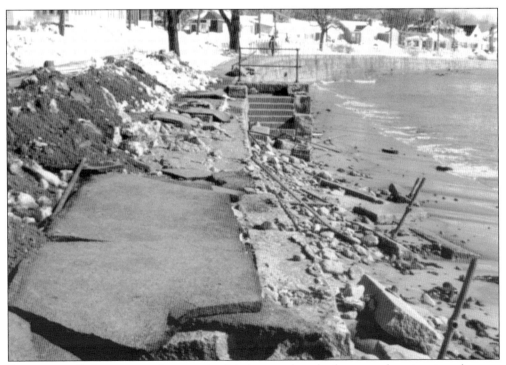

Severe seawall damage can be seen in this image, though the exact location is unknown. (Photograph courtesy of U.S. Army Corps of Engineers.)

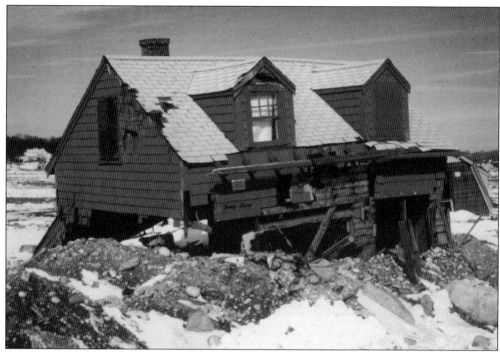

A demolished house in this photograph is surrounded by boulders and sand. (Photograph courtesy of U.S. Army Corps of Engineers.)

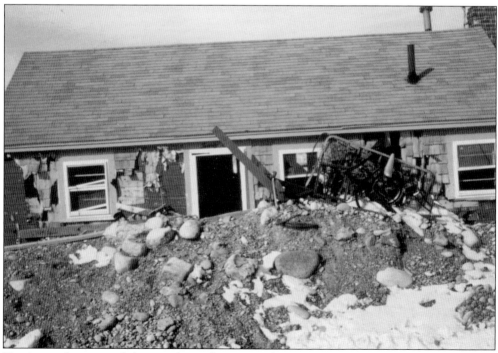

Here's another coastal house—beyond repair—that a government photograph captured. (Photograph courtesy of U.S. Army Corps of Engineers.)

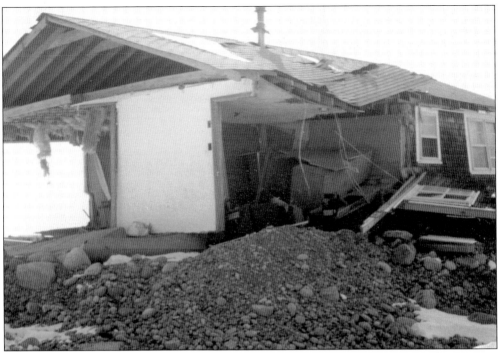

This close-up shows another house damaged by the storm. (Photograph courtesy of U.S. Army Corps of Engineers.)

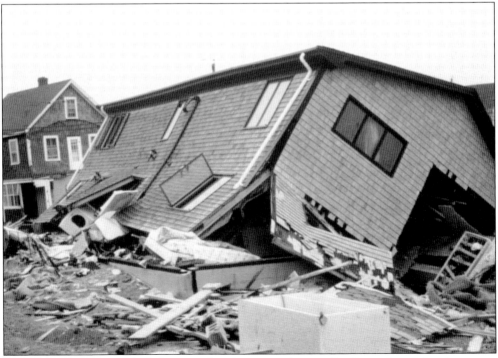

This home has been lifted from its foundations and partially dismembered by the storm. (Photograph courtesy of U.S. Army Corps of Engineers.)

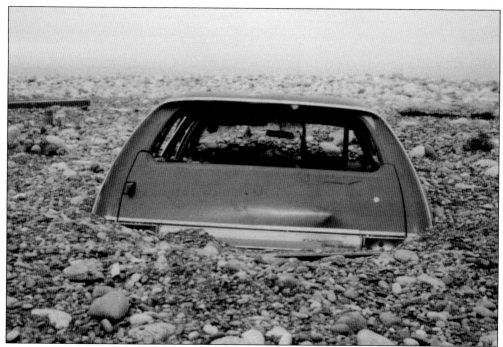

One of the most telling images to come from the storm, this station wagon has been partially buried by rocks and boulders thrown up by the sea. (Photograph courtesy of U.S. Army Corps of Engineers.)

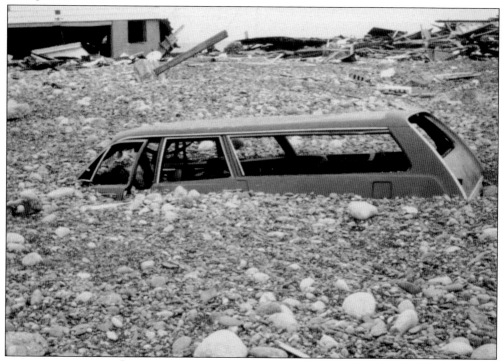

Another view of the same car shows the huge area that the storm filled with stones and debris. (Photograph courtesy of U.S. Army Corps of Engineers.)

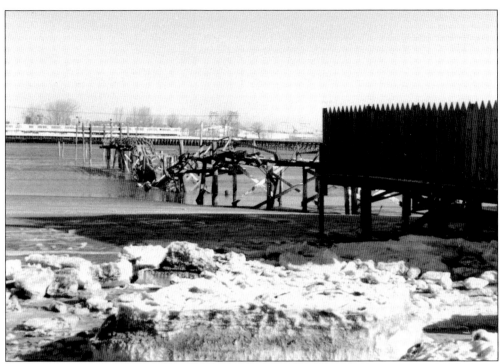

A wharf has been heavily damaged in this photograph. (Photograph courtesy of U.S. Army Corps of Engineers.)

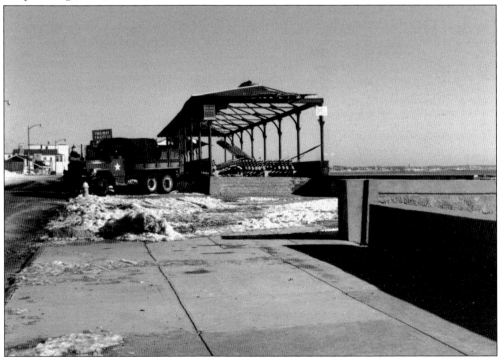

Pictured here are an army truck and a damaged pavilion along Revere Beach. (Photograph courtesy of U.S. Army Corps of Engineers.)

Revere Beach businesses, roads, and seawall were all hit hard by the storm. The Metropolitan District Commission police station is the building with the tower in the background. (Photograph courtesy of U.S. Army Corps of Engineers.)

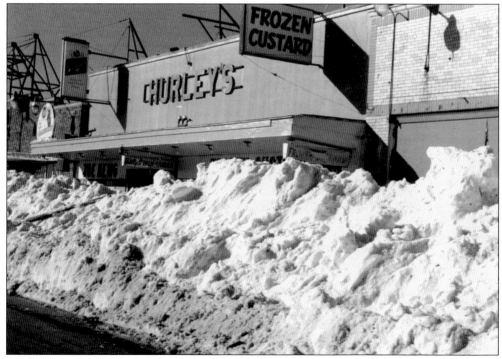

Anyone expecting to find frozen custard at Hurley's Palm Garden found instead only snow, ice, and dirt. (Photograph courtesy of U.S. Army Corps of Engineers.)

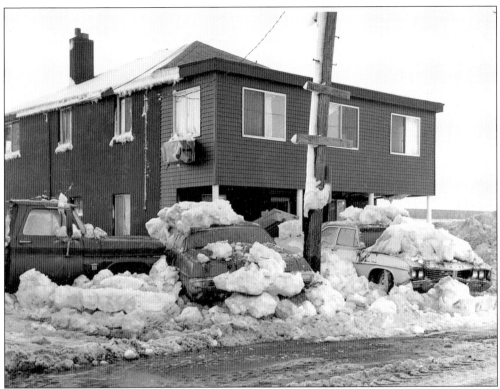

This photograph shows a house, probably in Revere, that managed to survive the storm. (Photograph courtesy of U.S. Army Corps of Engineers.)

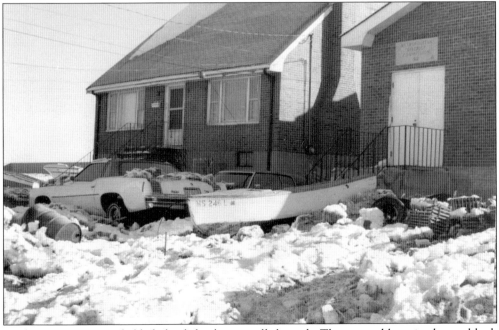

Brick construction probably helped this house pull through. The car and boat in the yard look like they have suffered more. (Photograph courtesy of U.S. Army Corps of Engineers.)

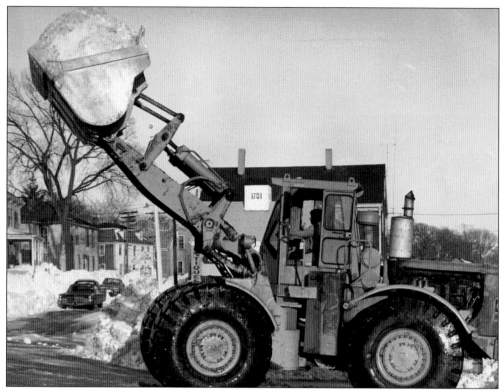

Digging out took a combination of public and private resources. Here a privately owned front-end loader scoops up snow. (Photograph courtesy of U.S. Army Corps of Engineers.)

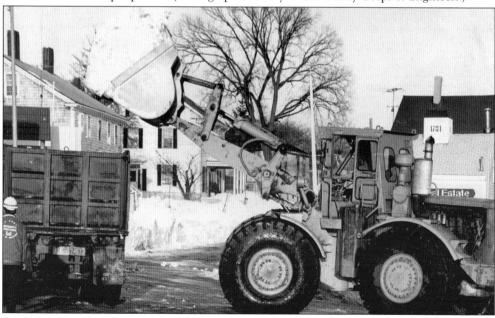

In this image, the front-end loader prepares to fill a dump truck. On the left, an official from the U.S. Army Corps of Engineers watches. (Photograph courtesy of U.S. Army Corps of Engineers.)

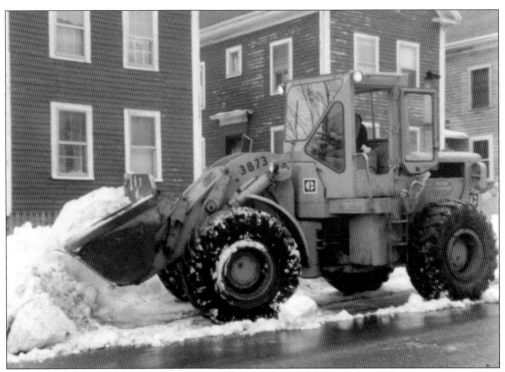

Another front-end loader has its work cut out for it in this North Shore street. (Photograph courtesy of U.S. Army Corps of Engineers.)

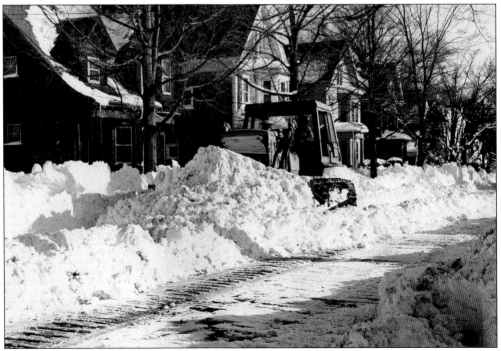

In this image, a bulldozer is clearing a Brockton street. (Photograph courtesy of U.S. Army Corps of Engineers.)

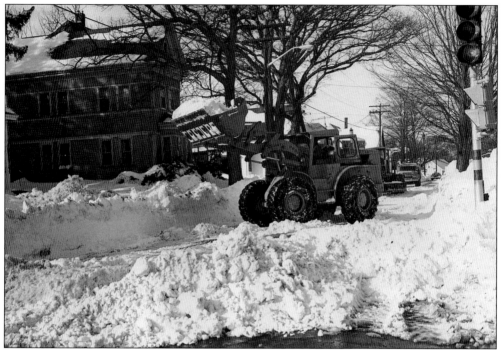

Here, in a scene reminiscent of the children's book, *Katy and the Big Snow*, a front-end loader and grader team up to clear the snow, followed at a respectful distance by an oil delivery truck and another vehicle. (Photograph courtesy of U.S. Army Corps of Engineers.)

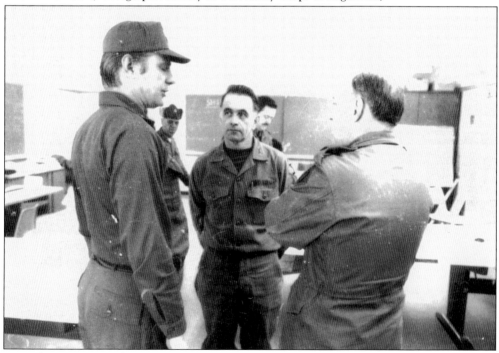

Massachusetts National Guard officials meet to discuss blizzard operations. (Photograph courtesy of Massachusetts National Guard.)

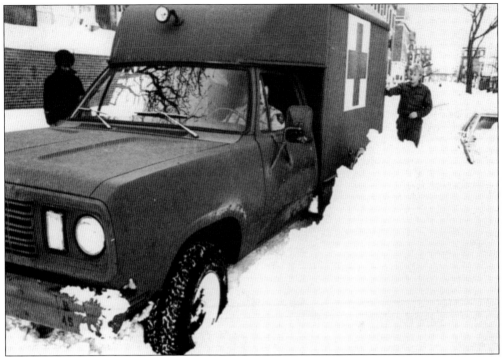

A Massachusetts National Guard ambulance is shown here on duty during the blizzard. (Photograph courtesy of Massachusetts National Guard.)

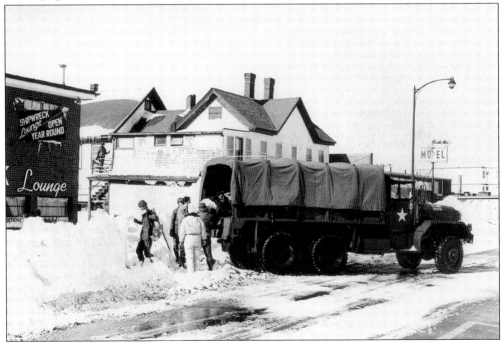

A Massachusetts National Guard six-by-six truck delivers supplies and equipment near the landmark Shipwreck Lounge on Revere Beach. (Photograph courtesy of Massachusetts National Guard.)

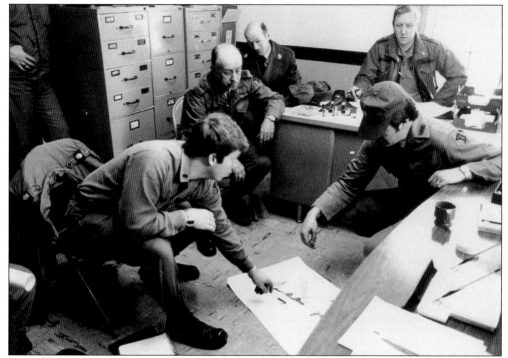

Another group of officers discusses army deployment details for the blizzard. (Photograph courtesy of U.S. Army Corps of Engineers.)

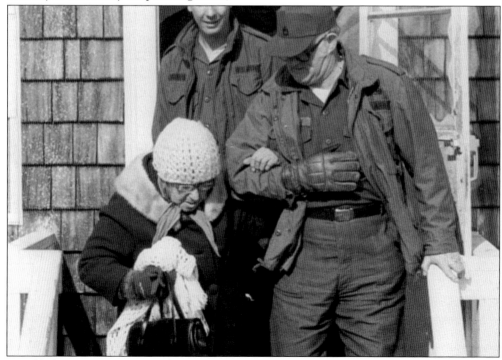

An elderly woman is evacuated by soldiers from the National Guard. (Photograph courtesy of Massachusetts National Guard.)

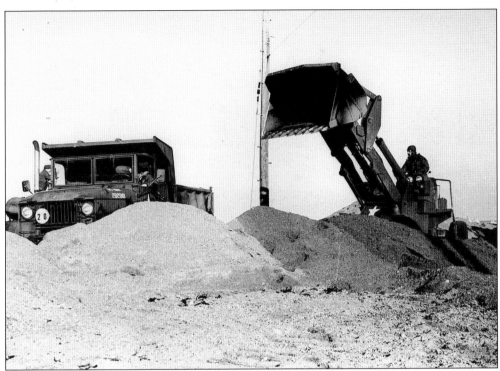

In this image, a National Guard dump truck and front-end loader team up to move sand along the shore. (Photograph courtesy of Massachusetts National Guard.)

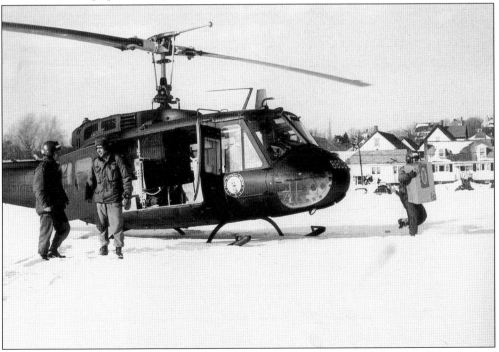

Here a National Guard helicopter delivers emergency food supplies. (Photograph courtesy of Massachusetts National Guard.)

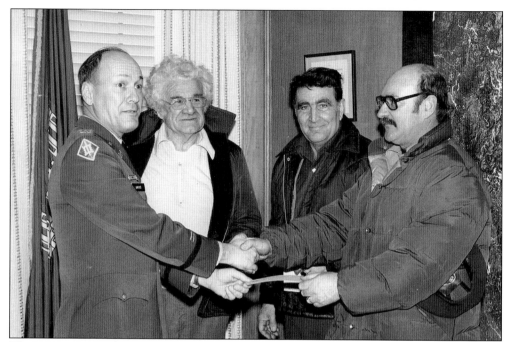

Three contractors who performed snow removal for the U.S. Army Corps of Engineers received checks and thanks from Col. Ralph T. Garver, deputy division engineer for New England. The contractors were George E. Lyons Jr. from Hyde Park, Harry G. Fantoni of Fantoni Company in Framingham, and Carmen Vozzella of Roslindale Contracting Company. (Photograph courtesy of U.S. Army Corps of Engineers.)

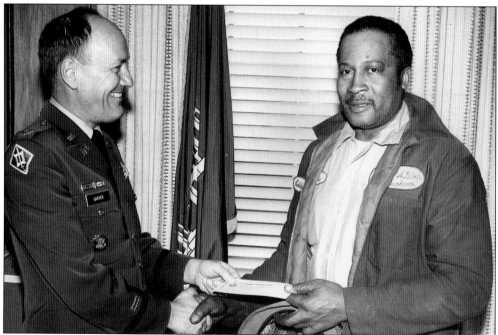

In this photograph, Colonel Garver presents a check and congratulations to another unidentified contractor. (Photograph courtesy of U.S. Army Corps of Engineers.)

Some chose to say no thanks. This Sudbury company declined payment for the work it performed during the storm.

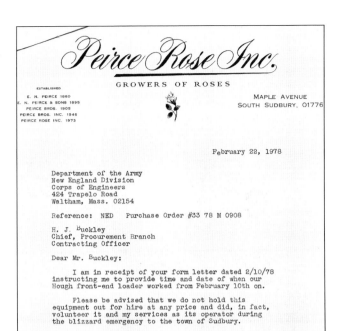

February 22, 1978

Department of the Army
New England Division
Corps of Engineers
424 Trapelo Road
Waltham, Mass. 02154

Reference: NED Purchase Order #33 78 M 0908

H. J. Buckley
Chief, Procurement Branch
Contracting Officer

Dear Mr. Buckley:

I am in receipt of your form letter dated 2/10/78 instructing me to provide time and date of when our Hough front-end loader worked from February 10th on.

Please be advised that we do not hold this equipment out for hire at any price and did, in fact, volunteer it and my services as its operator during the blizzard emergency to the town of Sudbury.

We feel strongly that under the conditions that existed at that period of time it was the very least that we could do for our town.

Sincerely,

Donald P. Peirce

DPP:mgm

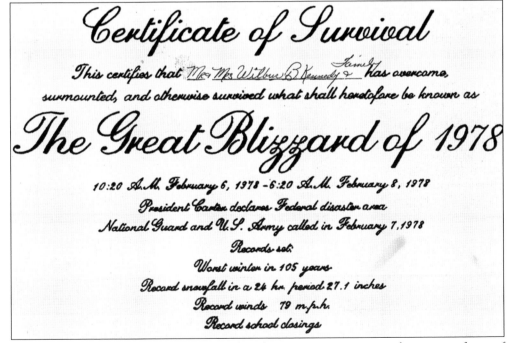

Certificate of Survival

This certifies that Mr. Mrs. Wilbur B. Kennedy & Family has overcome, surmounted, and otherwise survived what shall heretofore be known as

The Great Blizzard of 1978

10:20 A.M. February 6, 1978 – 6:20 A.M. February 8, 1978
President Carter declares Federal disaster area
National Guard and U.S. Army called in February 7, 1978
Records set:
Worst winter in 105 years
Record snowfall in a 24 hr. period 27.1 inches
Record winds 79 m.p.h.
Record school closings

For those who came through the storm, the ultimate memento was perhaps a certificate of survival. This one belongs to the Kennedy family of Quincy. (Courtesy of the Kennedy family.)

Discover Thousands of Local History Books
Featuring Millions of Vintage Images

Arcadia Publishing, the leading local history publisher in the United States, is committed to making history accessible and meaningful through publishing books that celebrate and preserve the heritage of America's people and places.

Find more books like this at
www.arcadiapublishing.com

Search for your hometown history, your old stomping grounds, and even your favorite sports team.

Consistent with our mission to preserve history on a local level, this book was printed in South Carolina on American-made paper and manufactured entirely in the United States. Products carrying the accredited Forest Stewardship Council (FSC) label are printed on 100 percent FSC-certified paper.

MADE IN THE USA